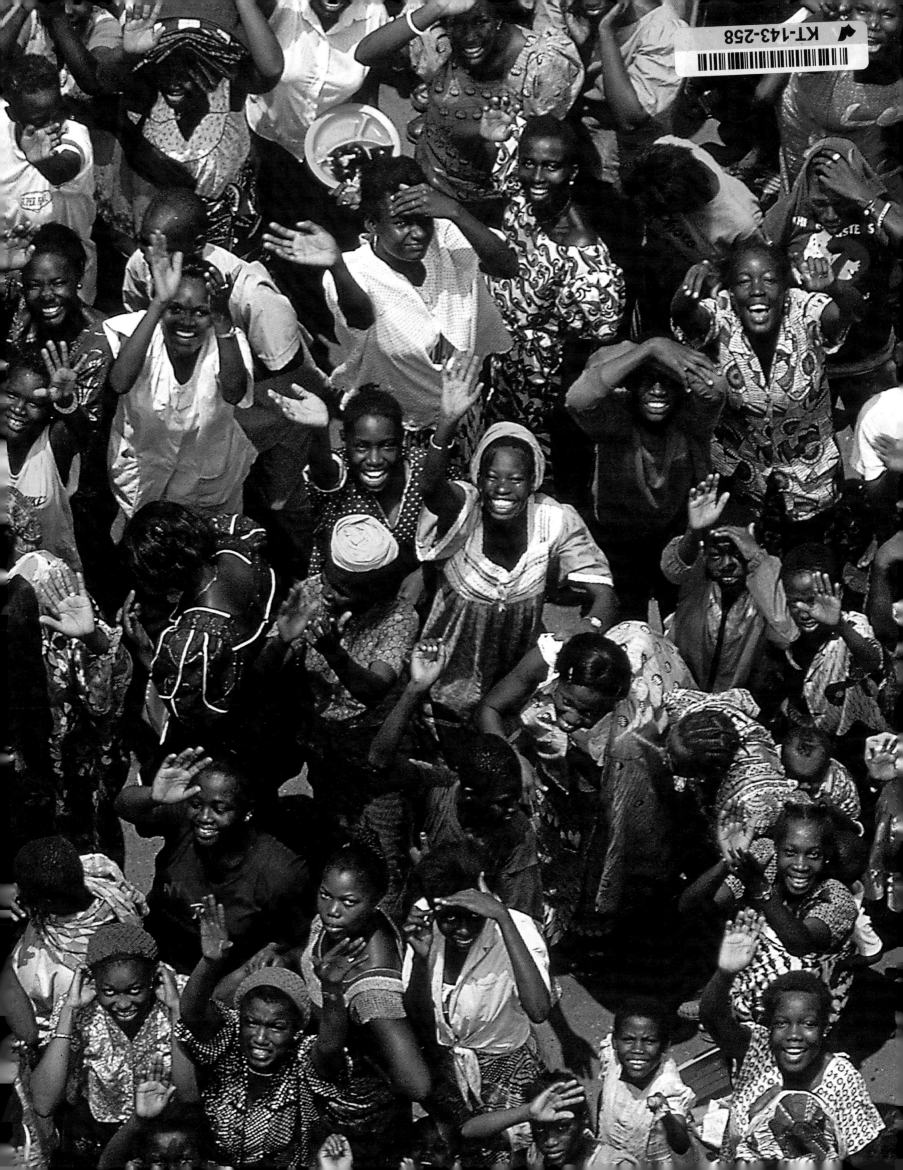

THE EARTH
FROM THE AIR
FOR CHILDREN

Translated from the French *La Terre racontée aux enfants* by Robert Burleigh

First published in the United Kingdom in 2002 by
Thames & Hudson Ltd, 181A High Holborn, London WC1V 7QX

Reprinted in 2003

Original edition © 2001 Éditions De La Martinière Jeunesse, Paris
Text © 2002 Robert Burleigh

British Library Cataloguing-in-Publication Data
A catalogue record for this book is available from the British Library

ISBN 0-500-54261-9

Printed in Belgium

Endpapers: Crowd in Abengourou, Côte d'Ivoire (Ivory Coast)

THE EARTH FROM THE AIR
FOR CHILDREN

Concept and photographs by
YANN ARTHUS-BERTRAND

Text by
Robert Burleigh

Illustrations by
David Giraudon

Thames & Hudson

Contents

My name is Jim.

I'm eight and a half years old. My godfather is Yann Arthus-Bertrand.
I love him because he's my godfather, but also because something exciting
always happens when you're with him. I don't see him every day, because he
travels a lot, but he sends me postcards when he's away, and now I collect them.
I have some from Nouméa, in New Caledonia, which is where he photographed
the heart that's on the cover of his big book, *The Earth from the Air*.

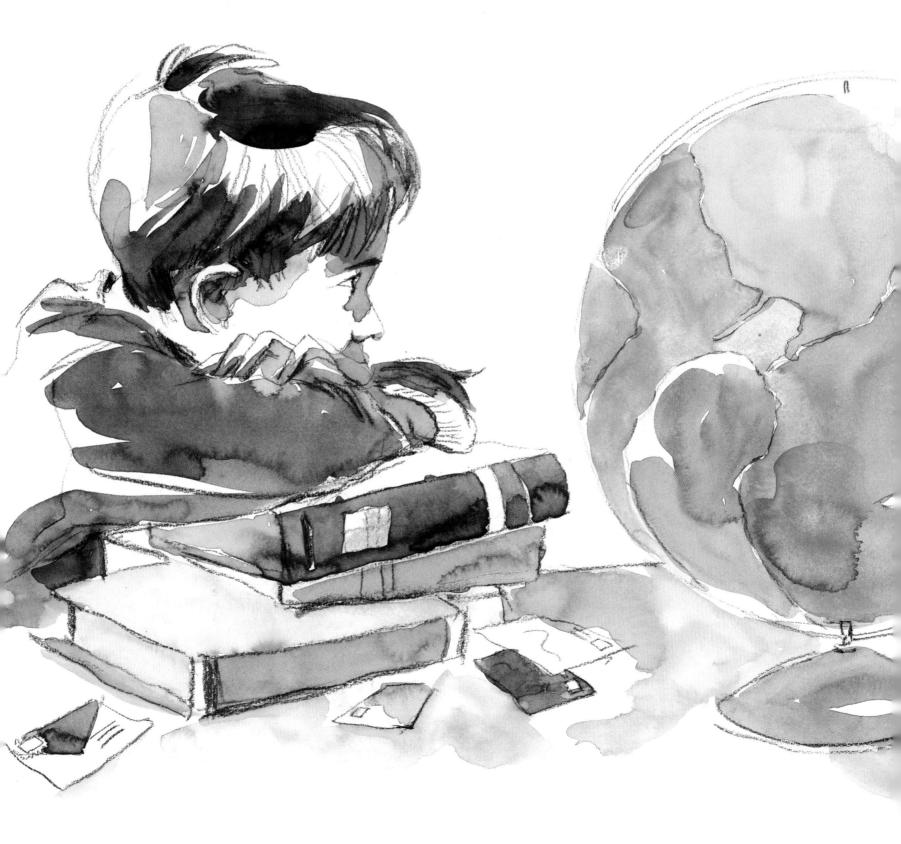

I really like that book. It's too heavy, but it's so beautiful. There are tons of pictures in it, not like the ones you usually see. The ones in the book are all different shapes and colours, and they come from the same countries as the postcards he sends me.

Yann's been to fifty countries at least. I like to look on a map and find the places he's been. I don't really understand how the earth is round and how we stay standing, but I like the earth a lot.

Last summer, I suspended an avocado pit over a glass of water, and roots grew. Then I planted it in the ground. Now it's a little tree, and every week I check that it's still growing. Yann says that trees are important. He says there are people who cut down whole forests and that afterwards the climate changes. He goes to places in his helicopter where people don't always have enough to eat and drink. Some of them don't even go to school.

I wish I could go with him and see the world. I went up in a helicopter once. It was great! All the people look so little – even the people who think they're big are small. The houses, fields, villages, streams – I thought they looked like pieces of a puzzle.

One day I'll travel with him. I'll see all the continents, the ones where people are yellow, the ones where they're black, the ones where they're brown, the ones where they're white. Because Yann will be getting a little old, maybe he'll let me fly the helicopter or take pictures. Cool! If I'm the pilot, I'll take him to the place where the heart is. From way up high, it'll look little, and then we'll fly down to look at it closer, and it'll look bigger.

**I'll land on it,
then it will look very big to us,
so big, it will become our earth.**

How Yann works . . .

When he decided to photograph the earth, Yann didn't just stick a camera in his pocket, take a plane to other countries and then rent a helicopter when he got there. When you write it like that, it sounds really easy. But it's not!

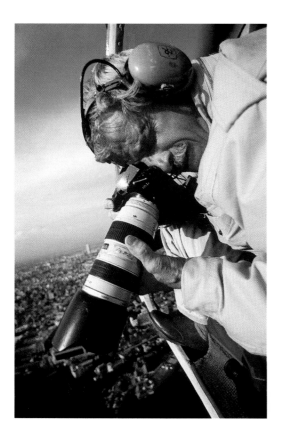

First Yann decided that he would photograph the world from up high. Not all the way up, not above the clouds, but high enough so that he could see the world and the people in a different way. A helicopter is great for that: you can go up or down, left or right, and very fast. But that's not so easy, either. You have to adapt the helicopter. You have to take one of the doors off so that Yann – securely attached – can lean out and look down, with his camera (which is quite heavy) glued to his eye. I'd feel a bit dizzy, but he doesn't.

Inside the helicopter, he's always moving around, always talking to the pilot. I say 'talking' but it's more like shouting, so that the pilot can hear him over the sound of the engine. 'Go right, there, forward, a little more, no, now go down, left, left, there, that's good, yes, that's good, go forward a little more . . .'

Meanwhile you hear the camera clicking, punctuating the words. It takes total concentration. He's always looking for the right angle, the right light, the right subject. But most of all he has to see the whole landscape, identify what's interesting. He has to see what we will like looking at.

That's what happens when Yann takes photographs. Before that, though, comes the preparation. He has to choose the countries, which isn't so easy, because not every government will give permission to fly over its territory, usually for security reasons. So he has to get authorizations, fill out forms, make telephone calls, wait. When he finally gets the authorization, he has to study maps of the country, locate the interesting places.

What's awful is when he finally gets the authorization, makes the trip to the place, is all ready to fly – and then the weather report says, 'Overcast skies, rain in the forecast.' The weather is the hardest part, because you can go ahead and ask the sky for a change of weather, but there's no one to hear either your request or your prayers. So you wait until the weather clears and the visibility is good, which is obviously absolutely necessary.

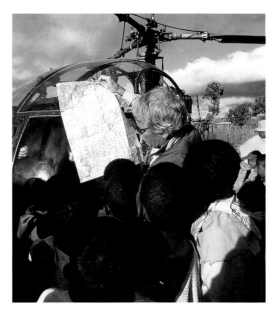

There is one thing that is as important to Yann as the weather, and that's having a perfectly trained crew around him. His office in Paris is in constant contact with him, ready to solve any problems. He also has an assistant who goes with him on all his trips. That assistant has to know him well, understand what he wants, and be ready for anything – even to be set down on an iceberg to show how big it is compared to a human being, so the people who eventually look at the photograph will realize how huge the landscape is. (Of course, then Yann goes down to get the assistant back – it would be a little rough to make him walk back from Greenland!)

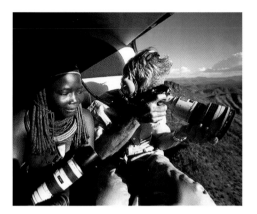

That, briefly, is what Yann's work is all about: the work of the man who photographs the world. He has visited almost one hundred countries, taken tens of thousands of pictures. Even if he goes on until he's ninety-nine years old, he'll never be done, because the world is huge, and it changes every day. So, like the book character the Little Prince, he'll go on being filled with wonder as he watches this world move. And then, one day, when he's gone to join the stars, others will take up where he left off. They'll be able to go to the exact same places he went, because its GPS (global positioning satellite) location is noted on every picture. They will be able to take the same pictures, and in that way we'll see the earth's evolution.

I say 'the same pictures', but I'm not so sure. I think Yann has a little light in his heart that others don't have, and it shows in every one of his pictures.

Hervé de La Martinière

A mangrove forest with heart

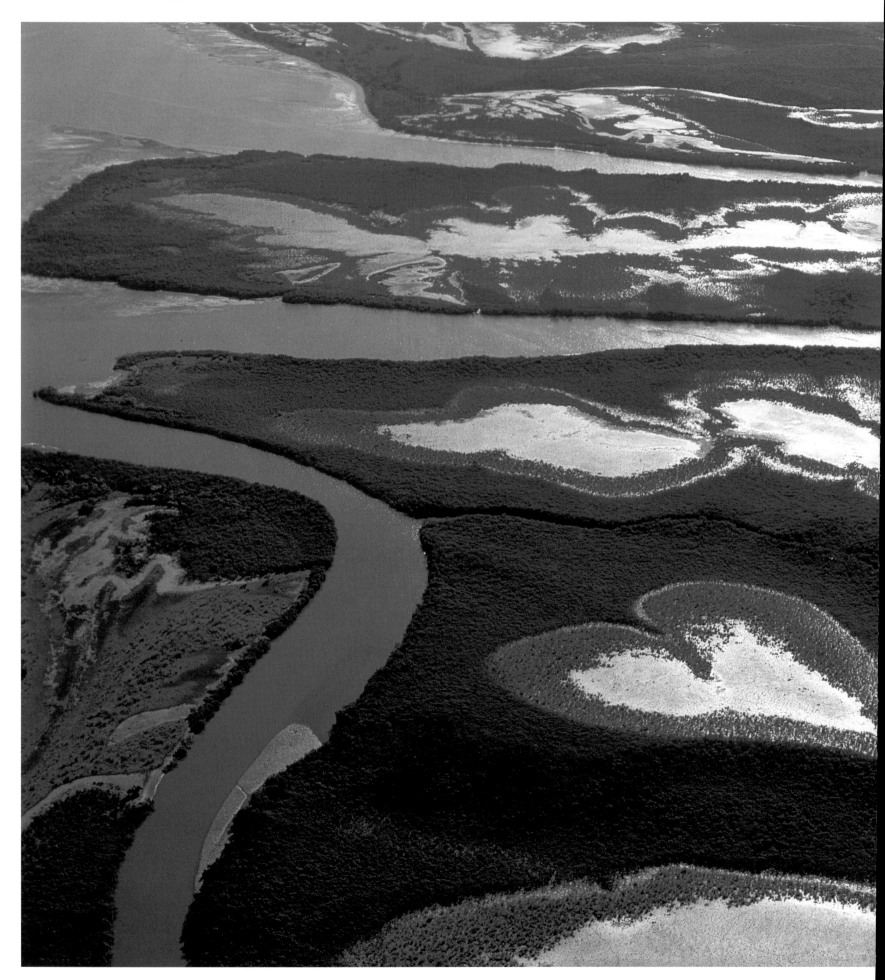

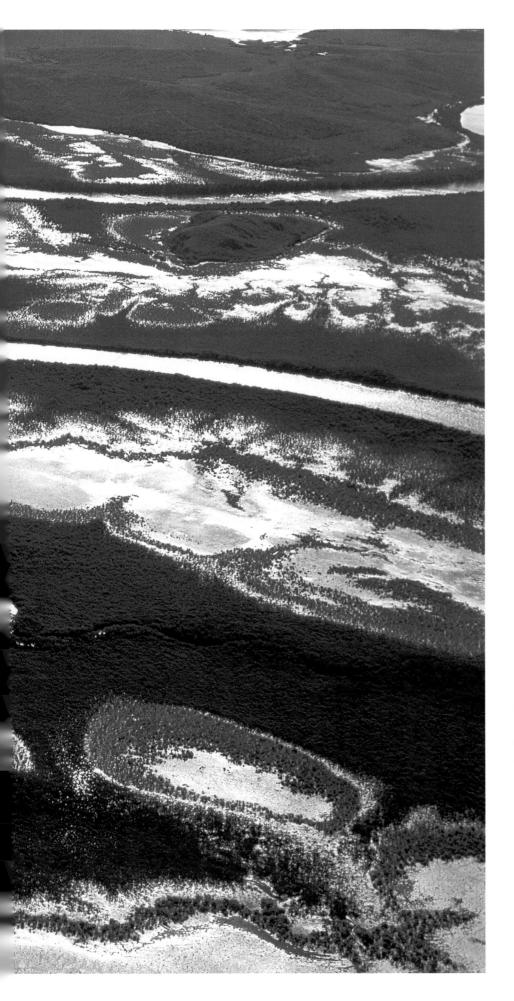

This mangrove forest is in New Caledonia, an island near Australia in the southern Pacific Ocean.

We're way above the earth, high above three rivers flowing out to sea. But what are the rivers flowing through? And what is that strange-looking heart?

We're looking down on a mangrove forest, often found in tropical regions. As warm river water nears the ocean, the shallow, muddy shoreline becomes a perfect growing place for thousands of mangrove trees. The trees thrust upward, fighting for light, while under the water, among the dark roots, swirls of fish, snakes and crocodiles hunt.

The mangrove forest is always changing. The heart is a natural clearing – a place where the ground is slightly higher, which causes the salt water to evaporate faster. The sand is saltier in these high spots; vegetation cannot grow here.

But because nothing stays the same for long in the mangrove forest, the heart could be gone in a year, or ten years, leaving nothing we recognize except the thick green growth.

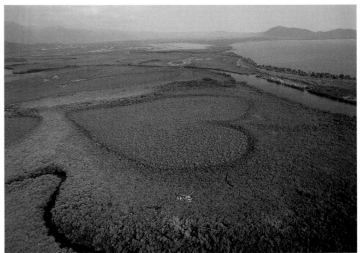

In the large picture of the heart, taken in 1991, the sand is clearly visible because the saltiness of the soil has discouraged plant growth. In the smaller picture, taken in 2002, the bushes have filled in the heart again because the salt levels in this particular spot have dropped. In a few more years, the landscape could change again.

Elephants on the go

The elephants in the photograph are among the many thousands that live in Botswana, in southern Africa.

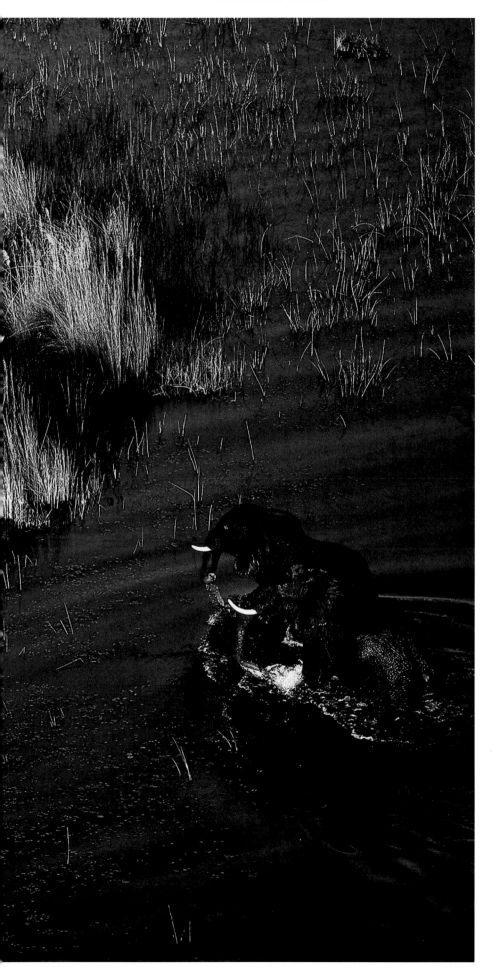

Two elephants are on the move. They're crossing a small lake in the Okavango Delta, heading towards another delicious elephant meal. Heavy as they are, they can swim. Elephants weigh a lot, but they also have large lungs, and these air-filled bags act as buoys, helping the animals stay afloat as they paddle across the water.

The long shadows mean the sun is rising or setting. It's during this cooler time – dawn or twilight – that the African elephant likes to be on the go.

Elephants are big eaters, and they eat only plants – hundreds of pounds every single day. They use their long trunks or their powerful tusks to uproot their food. But despite the fact that elephants present no danger to humans, some people hunt and kill these creatures for the ivory in their tusks, which is used to make things like jewelry. There are many laws designed to protect them, but huge and strong as they are, elephants are still in danger.

Scarlet ibis brighten the sky

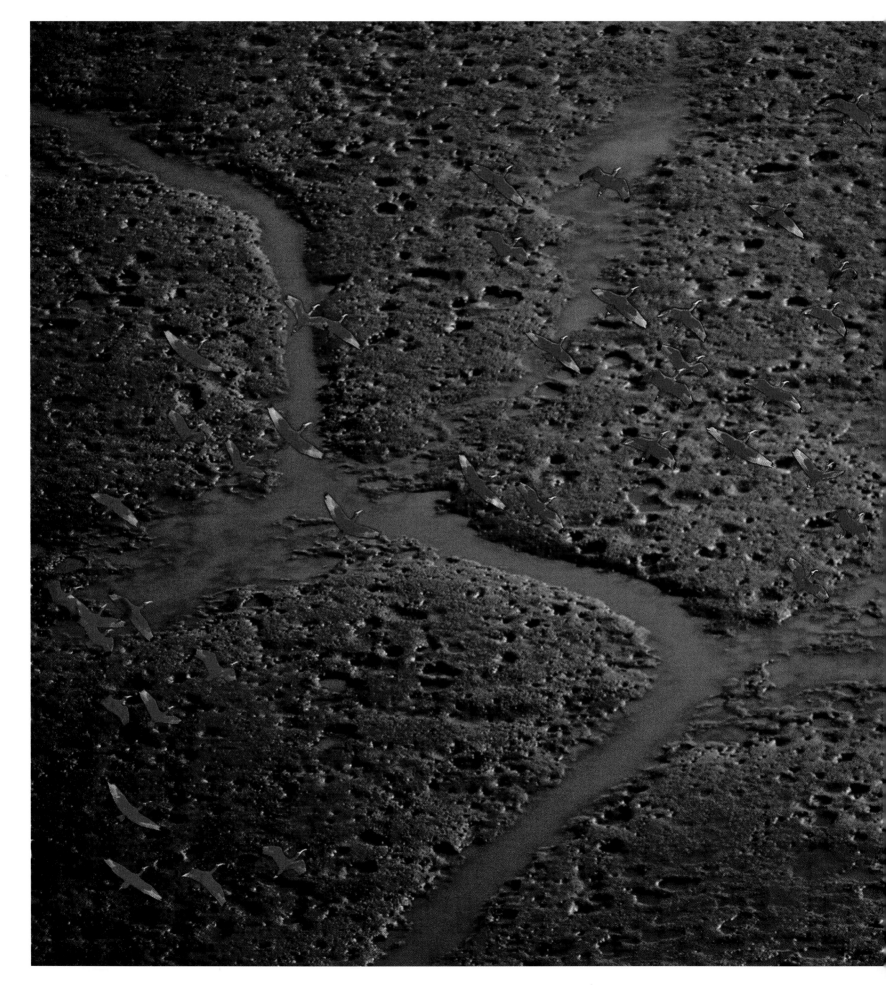

Venezuela, the country of the scarlet ibis, is located in the northern part of South America.

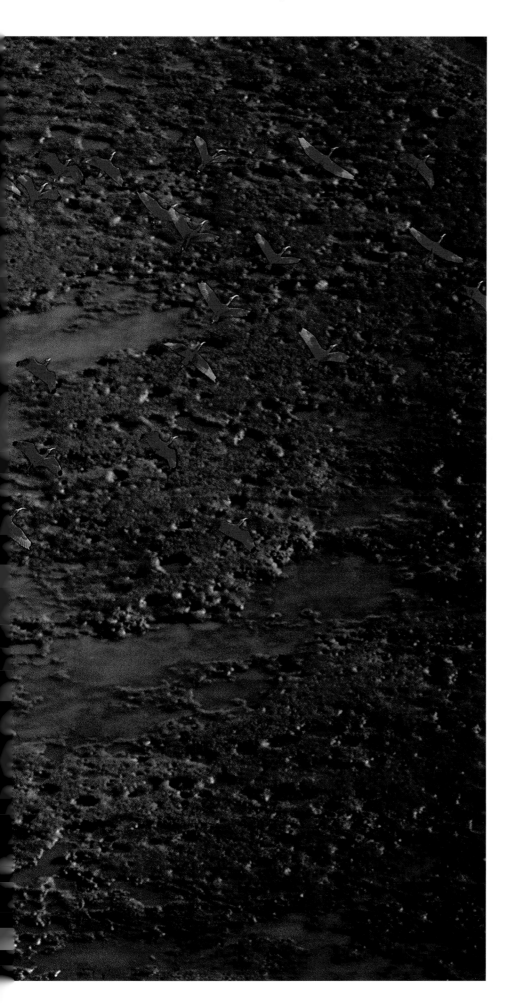

A flock of wide-winged, brilliantly coloured birds soars above a landscape that almost looks like the moon. But it isn't the moon – it's right here on earth. This flock of scarlet ibis is about to fly down to its feeding grounds in the Amacuro Delta of Venezuela.

A delta is an area where a river splits into separate streams as it reaches the ocean. Far below, you can see the winding, curving waters and the dented, muddy green of the swampland.

But what about the red? First, look carefully at any one of the birds. The scarlet ibis wades on its tall, spindly legs in the shallow water. Then, with its sharply pointed, curved bill, it goes fishing for shrimps and crabs. And that's where the red colour mostly comes from. The bodies of these small sea creatures contain a substance called carotene that makes the ibis feathers turn red.

Unfortunately, there is a sad side to this story, too. The red feathers are so attractive that people hunt the ibis to collect them. They use the feathers to make artificial flowers. And because of this, the beautiful scarlet ibis is becoming rarer, year by year.

A garden in the desert

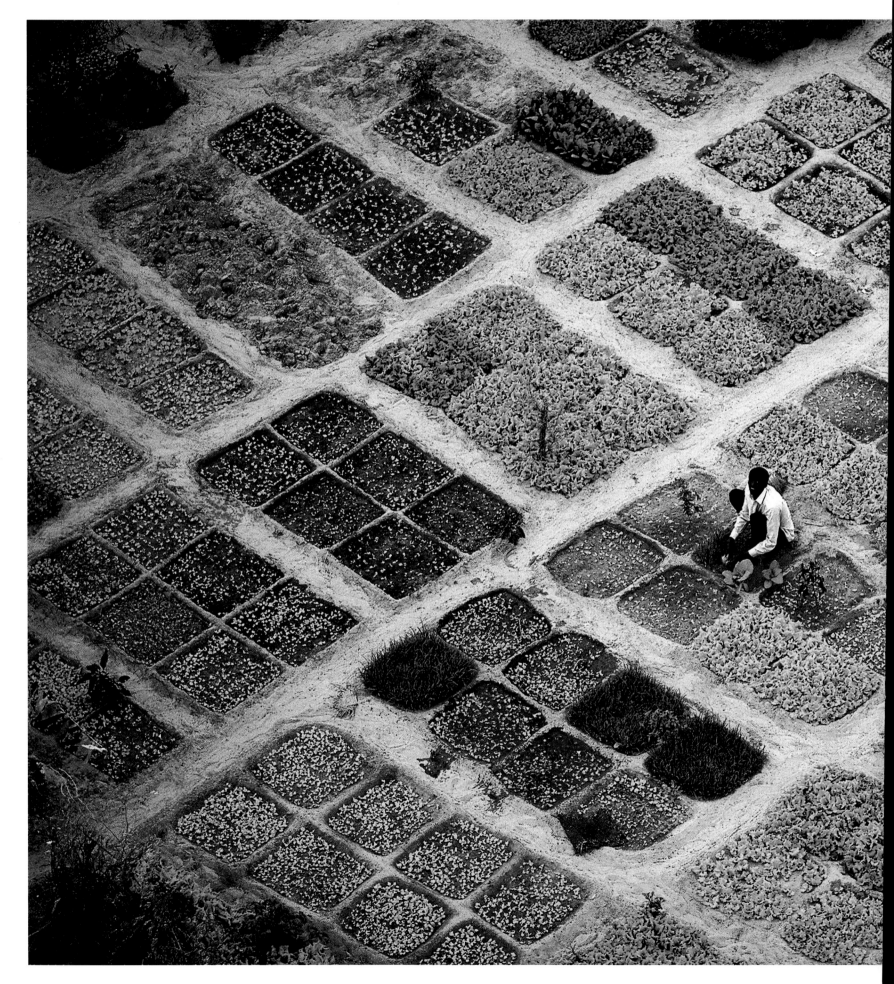

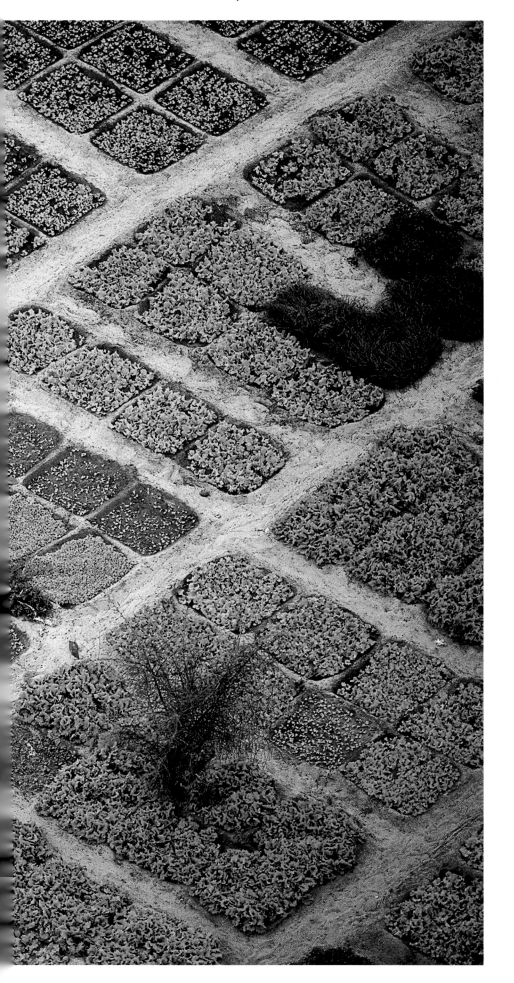

Inventive garden plots, like this one near Timbuktu, are transforming some of the dry-soil areas in Mali, a country in West Africa.

Can a garden grow in a desert? It can if you work to make it happen – as the man looking up at us is doing. Drought – lack of rain – has changed the way many people in West Africa live. The gardener in this photograph is an example of this fact.

You can see the dry, sandy soil that runs like a walkway around the outside of the garden plots. The large plots each contain six to eight small segments, and each segment, about a metre square, also has small walls enclosing it. Why? The answer is to keep the limited amount of water that the gardeners bring to the crops from running in all directions. The walls hold the water in one place, and it's in this place that the local people grow peas, beans, cabbages and lettuce. (You can see the lettuce right behind the man and in several of the other beds.)

This farmer was once a nomad – the name for a person or group that travels from place to place, tending herds as the animals graze in open, grassy places. But drought in this part of Africa has changed that. This man and his fellow tribespeople settled down, cultivated their gardens and created a new way of life in very difficult times.

A camel caravan

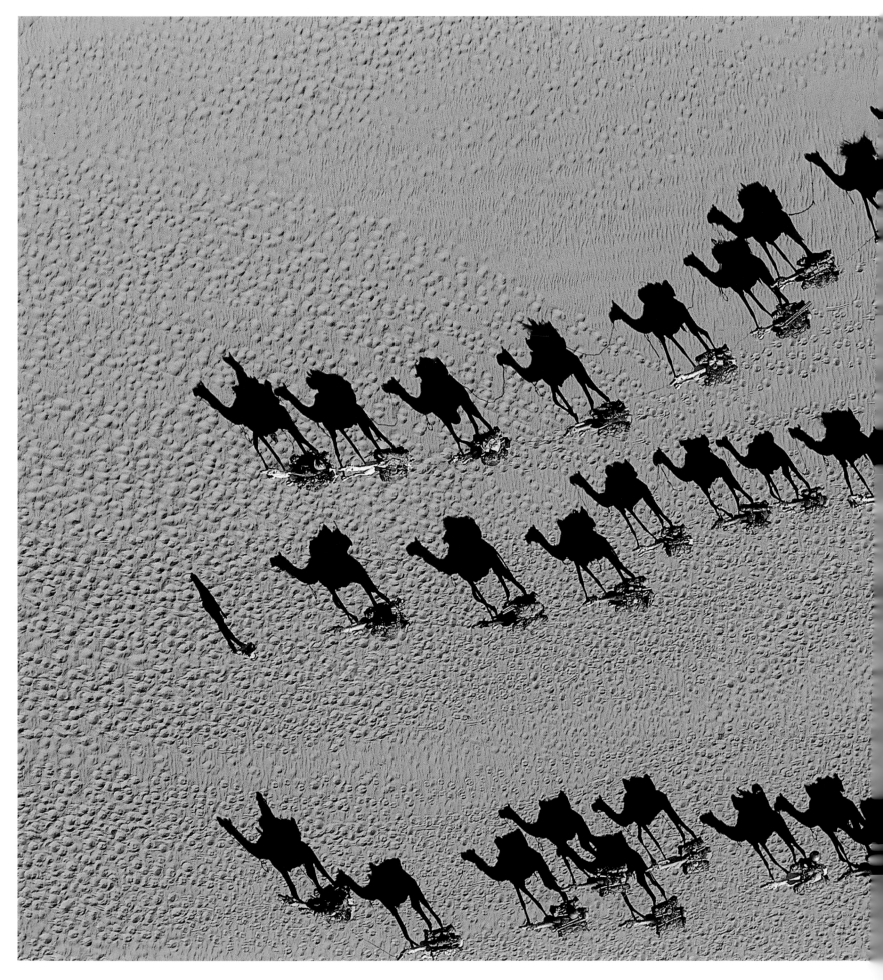

In the deserts of Niger, in western Africa, camel caravans can be seen carrying goods from place to place.

At first glance it may look like a dark, ghostly caravan, crossing the hot sands. But the black figures are really shadows extending from the bodies of three lines of dromedaries and their drivers. (Dromedaries are camels with one hump; Bactrian camels have two.) If you concentrate on the shapes at the feet of the shadow dromedaries, you can see the real camels, photographed almost exactly from above.

These 'ships of the desert' can carry heavy loads and go for long periods without water. In this picture, the large bundles on the dromedaries' backs mean that the men driving them have to walk. There are a couple of exceptions, though. You'll find them if you look at the leaders of two of the lines. Each man sits tall on his camel's hump.

What keeps the animals in line? Look carefully and you will notice the thin rope that ties dromedary to dromedary as they move, step by step, hour by hour, under the blazing sun.

Penguins prepare for a plunge

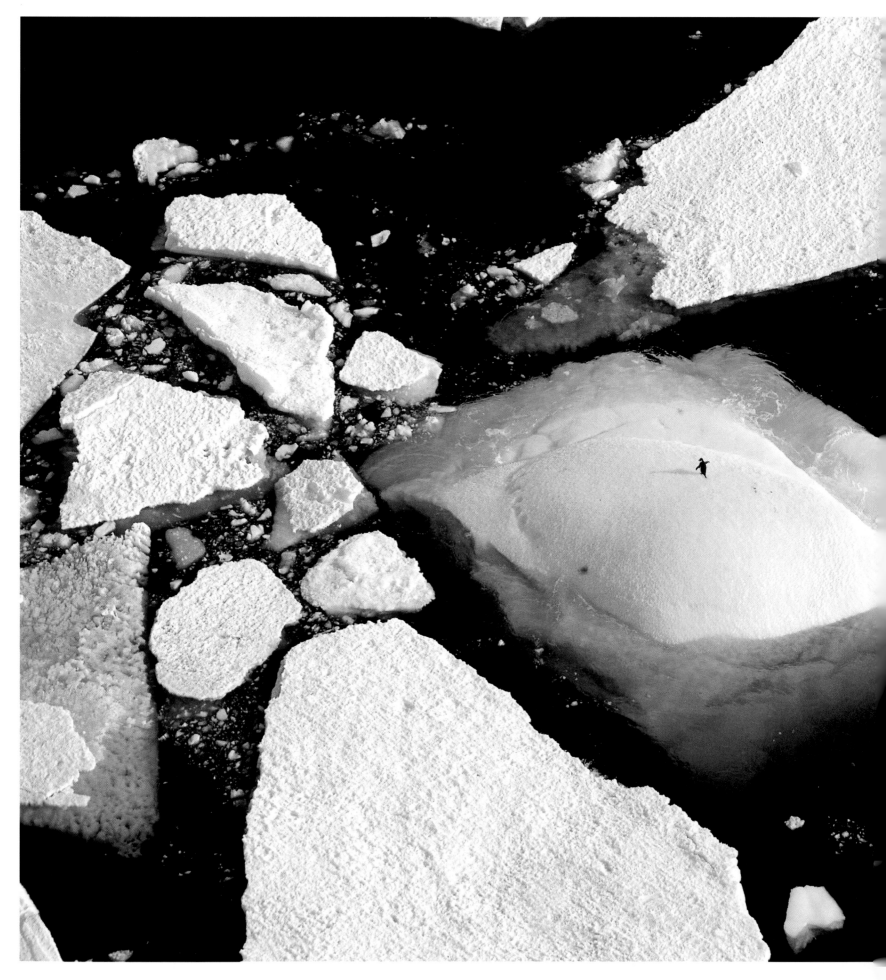

Penguins perch on icebergs in the cold, cold world of Antarctica, at the bottom of the earth.

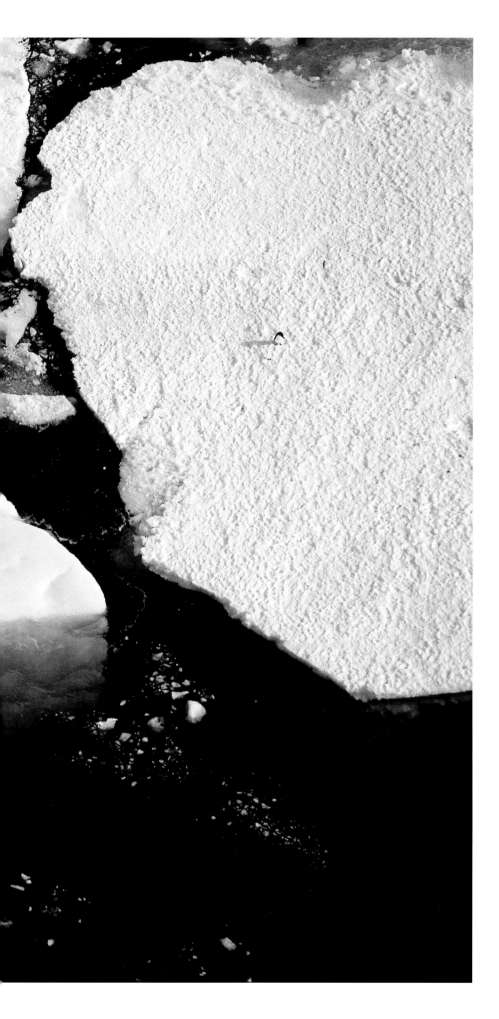

With its black flippers outstretched like arms to help it stay balanced, a penguin slides and waddles over the surface of a huge Antarctic iceberg. The iceberg (from a Norwegian word meaning 'mountain of ice') has broken off from a much larger wall of ice and is now floating freely in the cold water that surrounds the earth's southernmost continent. In fact, Antarctica is all ice – a large ice cap more than a mile thick.

People don't live in Antarctica, though they do visit as tourists or scientists. But it is home to penguins and seals, who sometimes ride the bergs as if they were rafts. Really *big* rafts! Most icebergs aren't just thin sheets of ice. As this picture shows, the underside of an iceberg descends far under the sea.

Look again and you can find another penguin. This one is better camouflaged, since its white belly blends into the snow. Both penguins are on their way to the water's edge. There they will plunge into the ocean, looking for fish. Can an awkward-looking penguin catch a speedy fish? You may be surprised. Penguins are strong, fast swimmers that can follow their prey down to depths of nearly three hundred metres.

A volcano blows its top

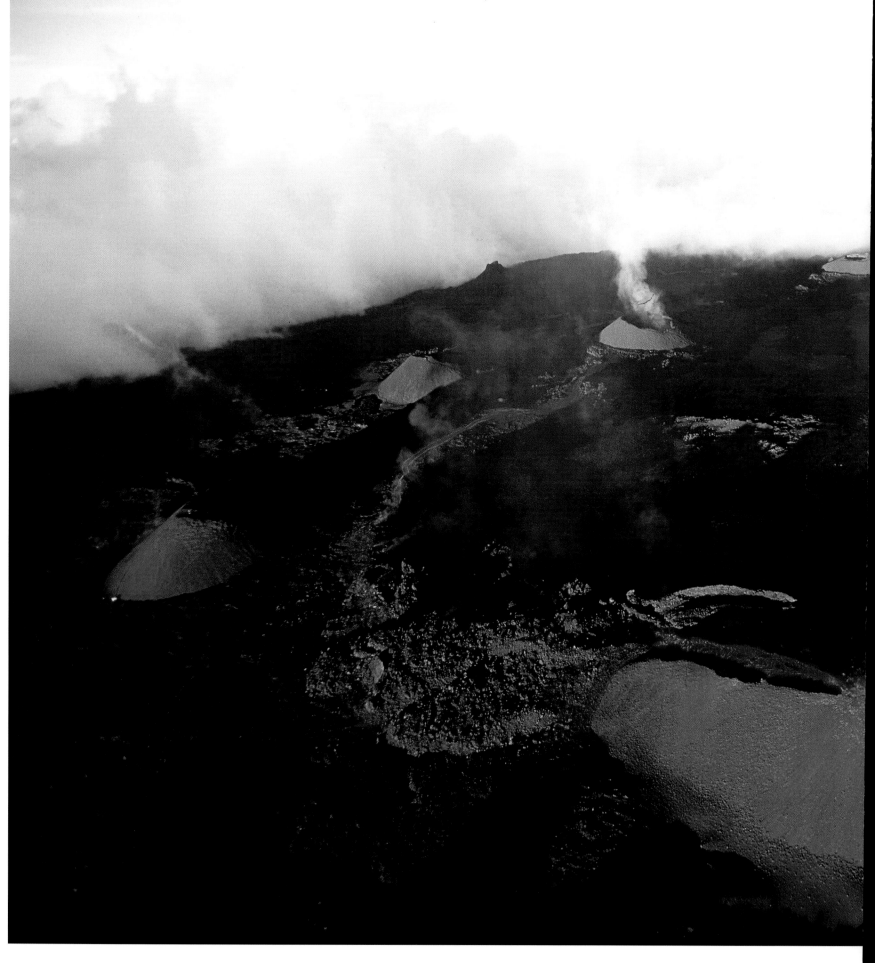

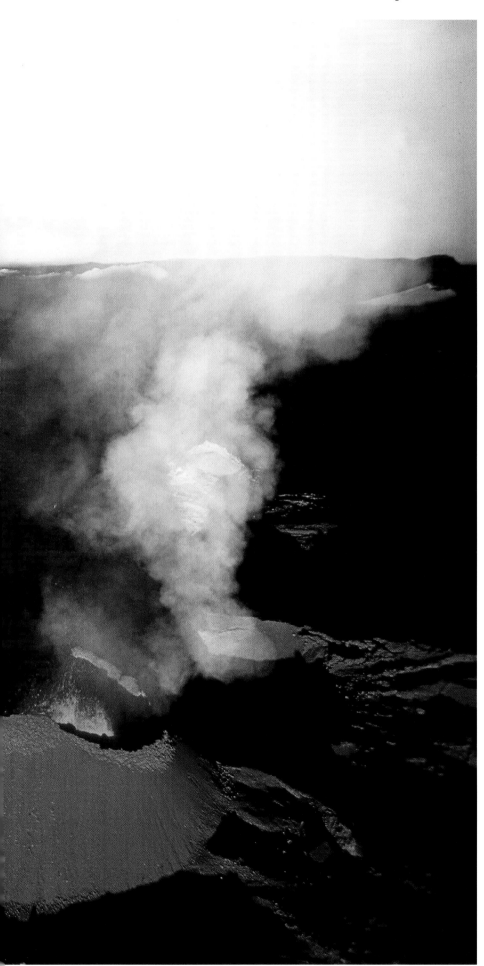

Look out above – and below! The smoke rising in great billows tells us there's fire somewhere. But what's burning, and why?

It's a volcano. You can see the flaming centre in the picture's lower right corner. Because our planet is young (in terms of geologic time), the centre of the earth is still a fiery mass. Usually we're protected from this terrible heat by the earth's solid crust. But not always. Sometimes the burning rock and the flames rise and force their way out. Then – *boom!* – a volcano erupts. The eruption causes dome-shaped craters to form, several of which you can see here. After the explosion, hot liquid rock, or lava, pours down the mountainside. The red lines in the photograph are streams of lava, which will slowly cool and finally turn to hard rock.

Do we know when a volcano is going to explode? We aren't perfect yet, but we are getting better at predicting these eruptions. Instruments placed inside the crater can measure the heat and the tremors of the shaking crater walls. This can tell scientists that something is about to happen. And when they know this, they warn people living in the area to get away – *now!*

Clouds of cotton

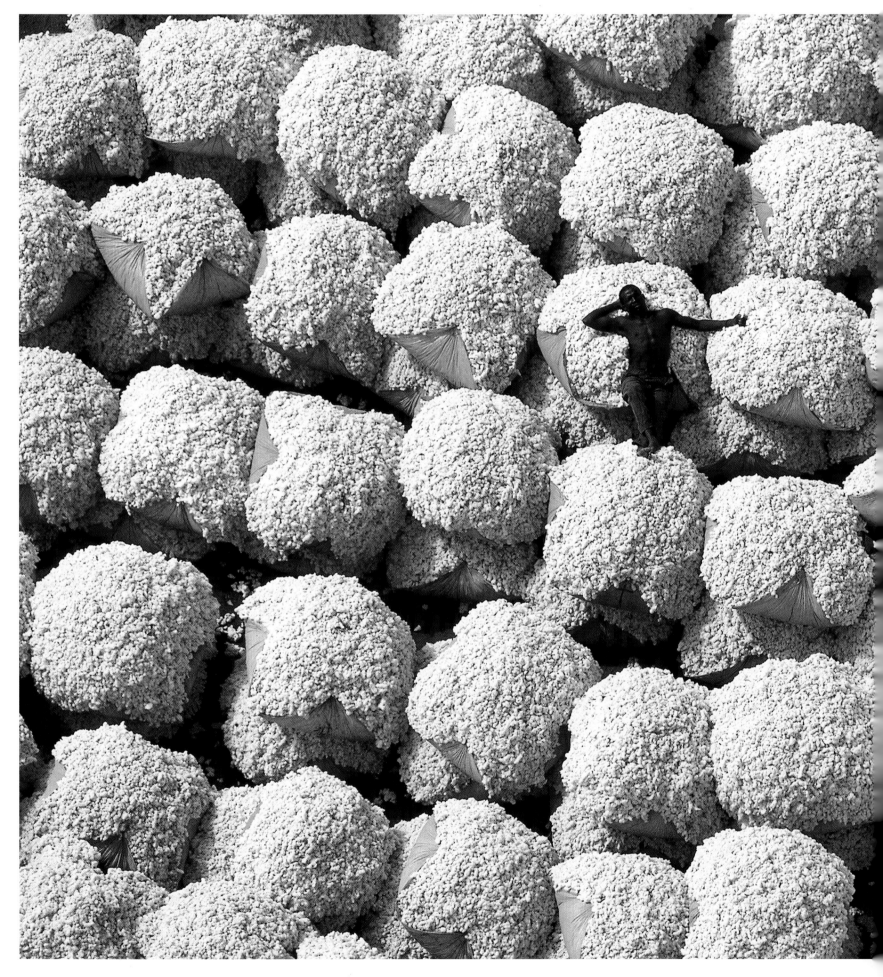

Côte d'Ivoire (Ivory Coast), located in West Africa, provides cotton that helps make clothing for many people in the world.

This man isn't resting on a king-sized cauliflower. We're looking down on a huge number of bales of cotton.

A cotton plant, like all plants, produces seeds. Each seed is surrounded by long, silky fibres. In the wind, these fibres would help the seed soar into the air and find a new place to grow. But when cotton is planted and harvested by people, workers pick the seeds. Then they collect the thread-entwined seeds in bales, each composed of many, many soft balls of cotton.

The bundles look like they are wrapped inside giant green leaves. But the 'leaves' are really squares of plastic tied at the four corners. Soon the bales will be transported to cotton gins, where the cotton fibres will be separated from the seeds and twisted together to make strong threads. And those threads will be used to make our clothes. It all starts here.

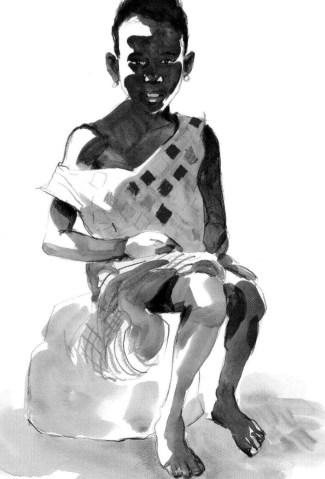

Fishermen repair their nets

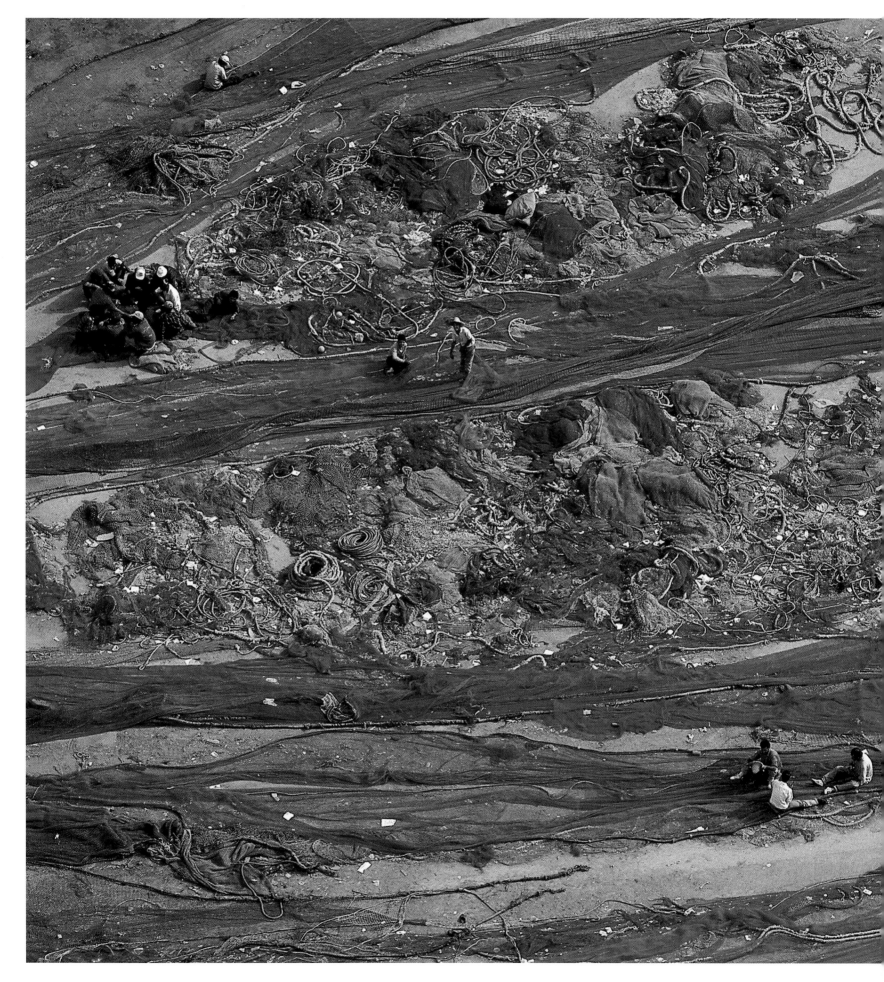

The city of Agadir, in Morocco, is the most important sardine-fishing port in the world.

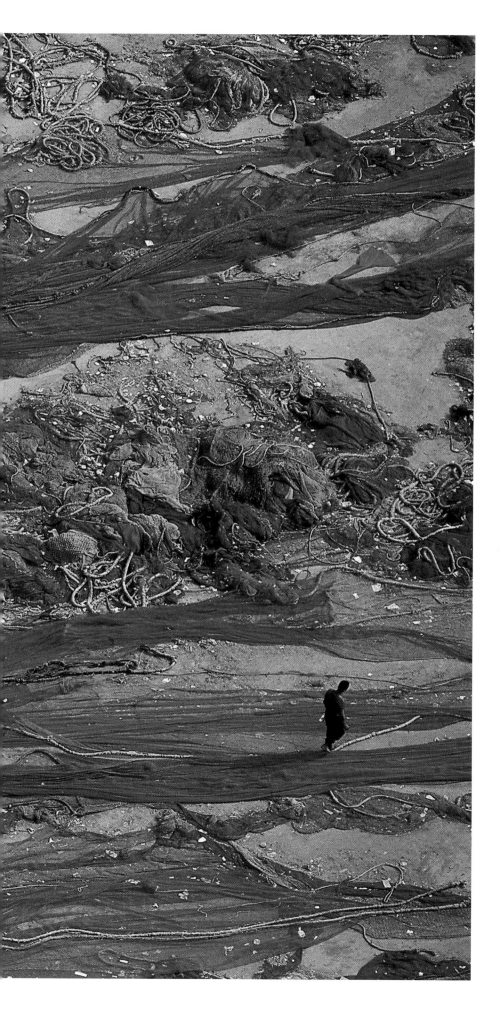

You may think you're looking at streams of blue water. But look again. The blue is the piled-up nylon nets of fishermen on the coast of northwest Africa. Every morning, after the men return with their boats, they haul the nets up on shore to get them ready for the next day's work.

The fishermen of the port city of Agadir, in Morocco, go fishing for small tasty fish called sardines. The nets are blue-coloured for a very good reason. When they are heaved into the water (the men hold on to the nets by the ropes you can see in the picture), the blue colour matches the ocean itself. Then the sardines, moving along and feeding on smaller creatures, swim into the nets.

The weight of the thousands of sardines creates small holes in the nets that must be mended. The fishermen use a special needle – a flat rod pointed at one end – to make their repairs. After that, it's time to rest until the next morning, when, before the sun rises, the fishermen of Agadir take to the sea once more.

Terraced rice fields

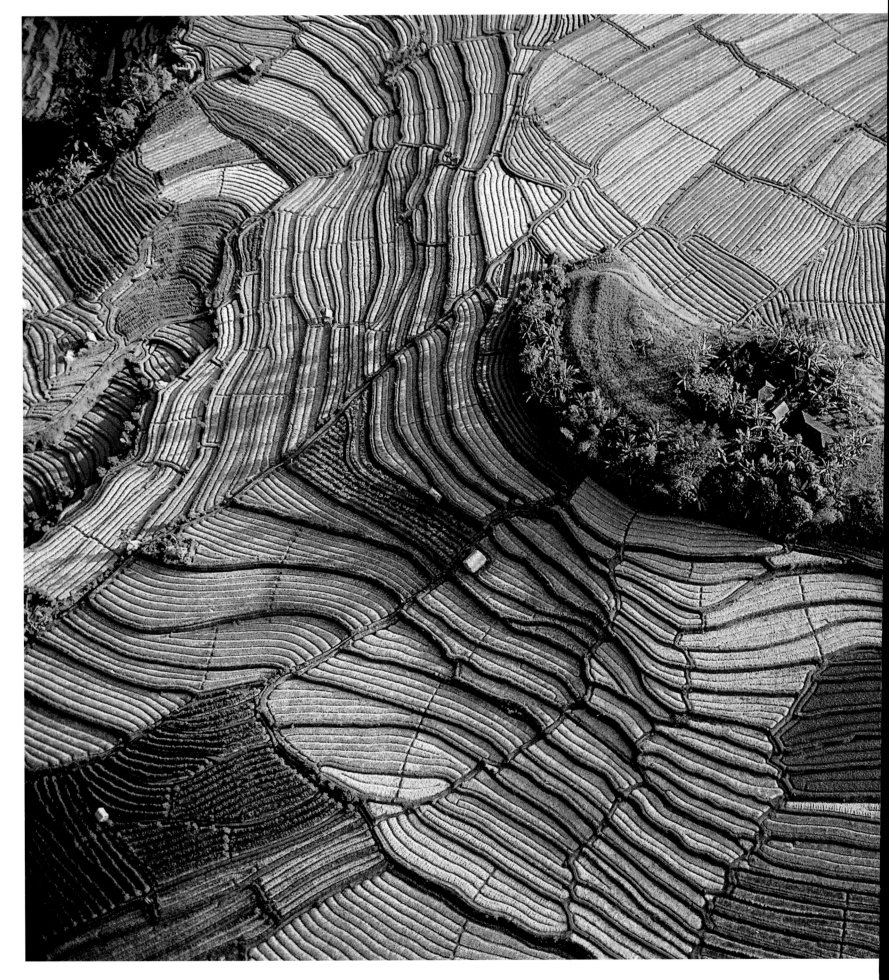

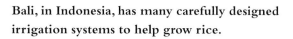

Bali, in Indonesia, has many carefully designed irrigation systems to help grow rice.

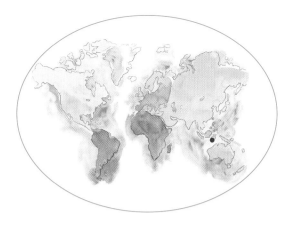

Drawing this design on a piece of paper – even with a compass and a ruler – wouldn't be easy. Think how hard it must have been to create such a carefully constructed landscape! But it's far more than a beautiful landscape. It's a complicated system of irrigation that helps feed many people.

Rice is grown in these fields. And rice needs lots and lots of water to grow. How does the system work? On the very top of the hillside (find the red buildings), water is drawn up from deep in the earth. Next, the water is allowed to flow down into the rice fields via a network of narrow canals. The water runs through each level, or terrace, irrigating the topmost terrace and then flowing further down to irrigate the lower terraces in turn.

Every segment in the photograph is one field of rice. That's a lot of rice, but it will all be used. In Asia, rice is the most important crop grown. Just as Westerners think of bread (made mainly from wheat) as a part of their daily diet, Asians think of rice as a staple to be eaten at every meal. That's why the people of Indonesia (and elsewhere) have worked hard to use the land wisely and well. It's a work of art – and it feeds people, too.

Village houses row on row

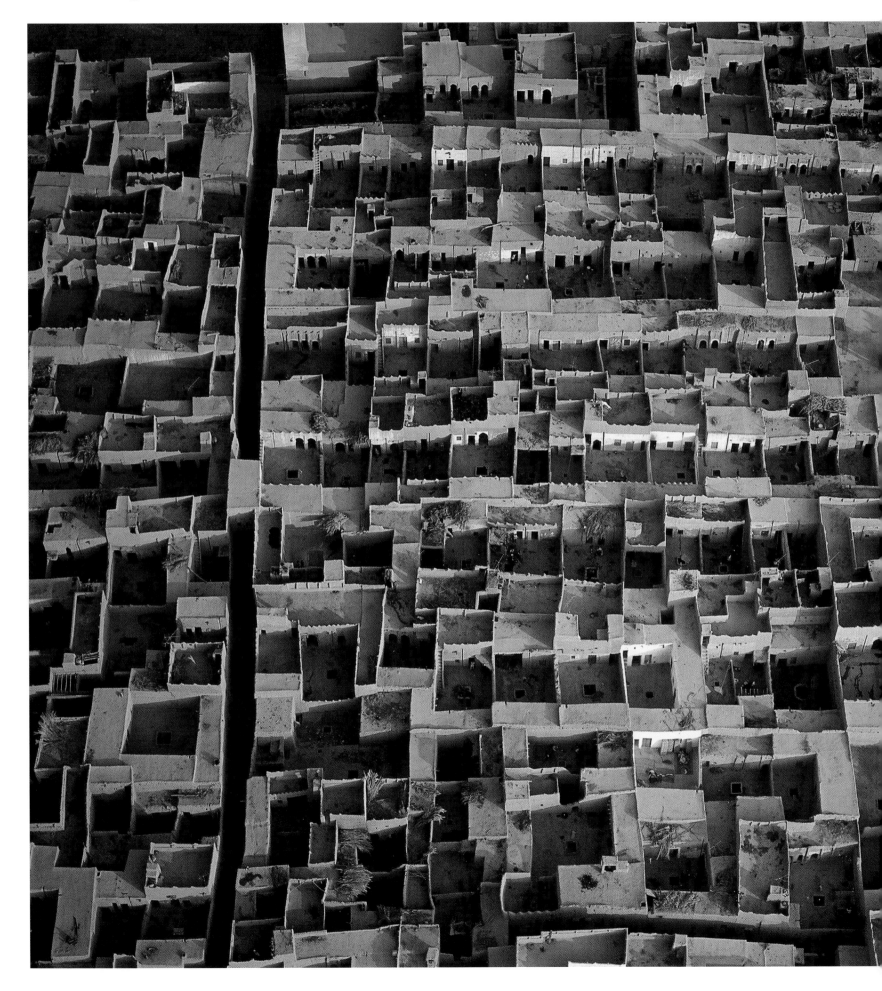

Morocco, located in northwest Africa, is a country of mountains and deserts.

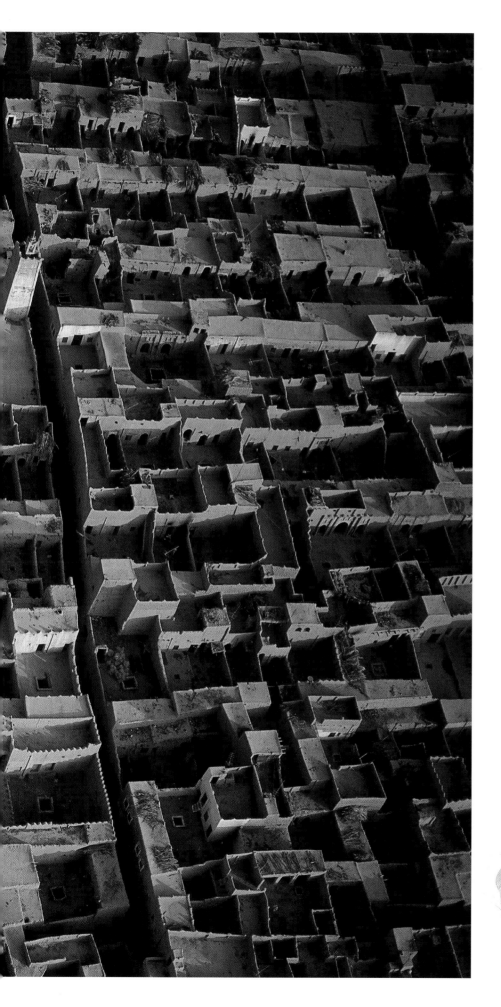

It almost looks like the model for a squared–off beehive – but we're actually gazing down on the flat rooftops of a mountain village. The houses are snug and very close together – for good reasons. By keeping their houses tightly side by side, the villagers shelter themselves from both the hot sun and the dust from the surrounding desert.

If you look carefully, you'll see bunches of crops lying on roofs here and there. The roof is an excellent place to dry crops in the sun as well as to keep them away from small animals. And each house has a kind of patio, too, extending from the inside rooms. On cool nights, the families come out to relax and talk quietly behind the high walls.

Can you find the two streets running from the top to the bottom of the picture? Those are the paths everyone here walks every day, to find their own home among so many others.

Steering through the Niger River

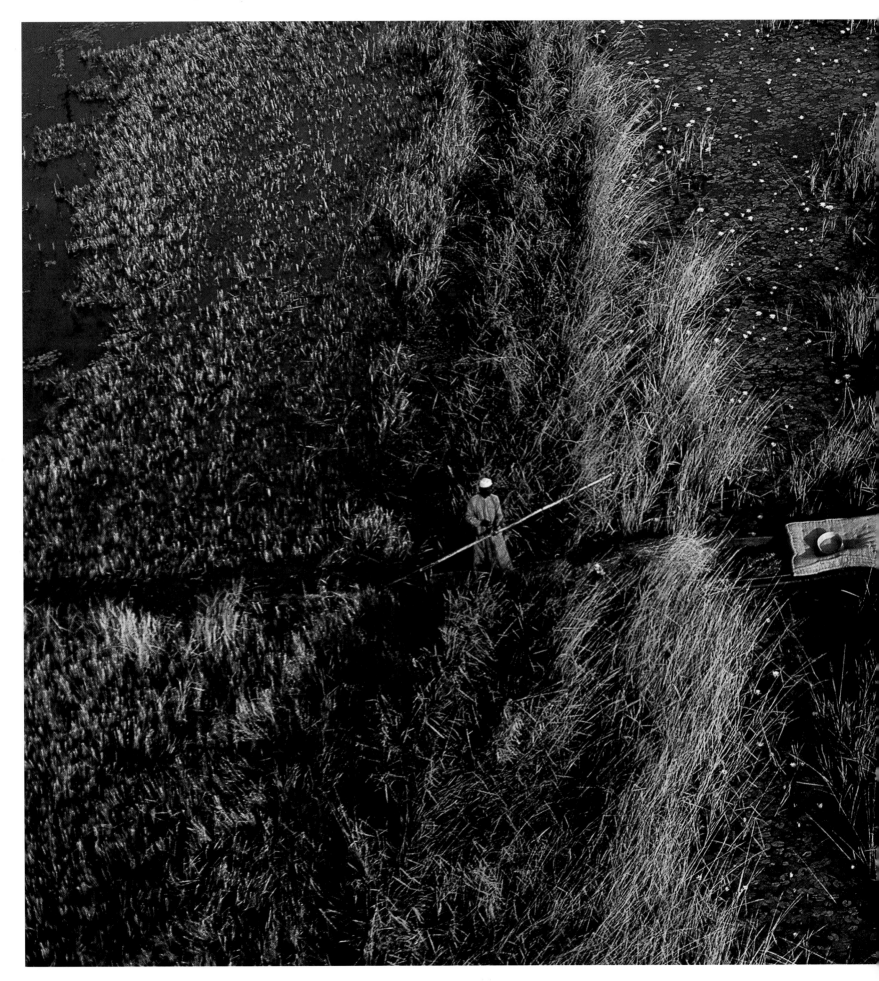

The Niger River runs through western Africa.

If you think the man in the photograph is walking on water, look closer. He is really standing on the back end of his narrow canoe. He is using his long pole, called a boat hook, to push and guide the canoe as it noses its way into the thick grassy area along the river's bank. Even the little children who live locally know how to do this.

Of course, the Niger River isn't always this difficult to steer through. Further out from shore, it becomes a calm, slow-moving body of water that is very important to the people of Mali. The Niger is, in one sense, like a road, and our boatman would switch from his boat hook to a paddle if he was moving up- or downstream.

The Niger rises and overflows its banks at certain times of the year. When it does, it helps irrigate many miles of farmland that lie alongside it. Here, many farmers of Mali grow rice (a plant that likes to have its roots in water), while other agricultural workers use the excess water in their small garden plots. But that's not happening just now. For the moment, the thoughts in the mind of the boatman are simple. Keep balanced. Push ahead!

Coast to coast

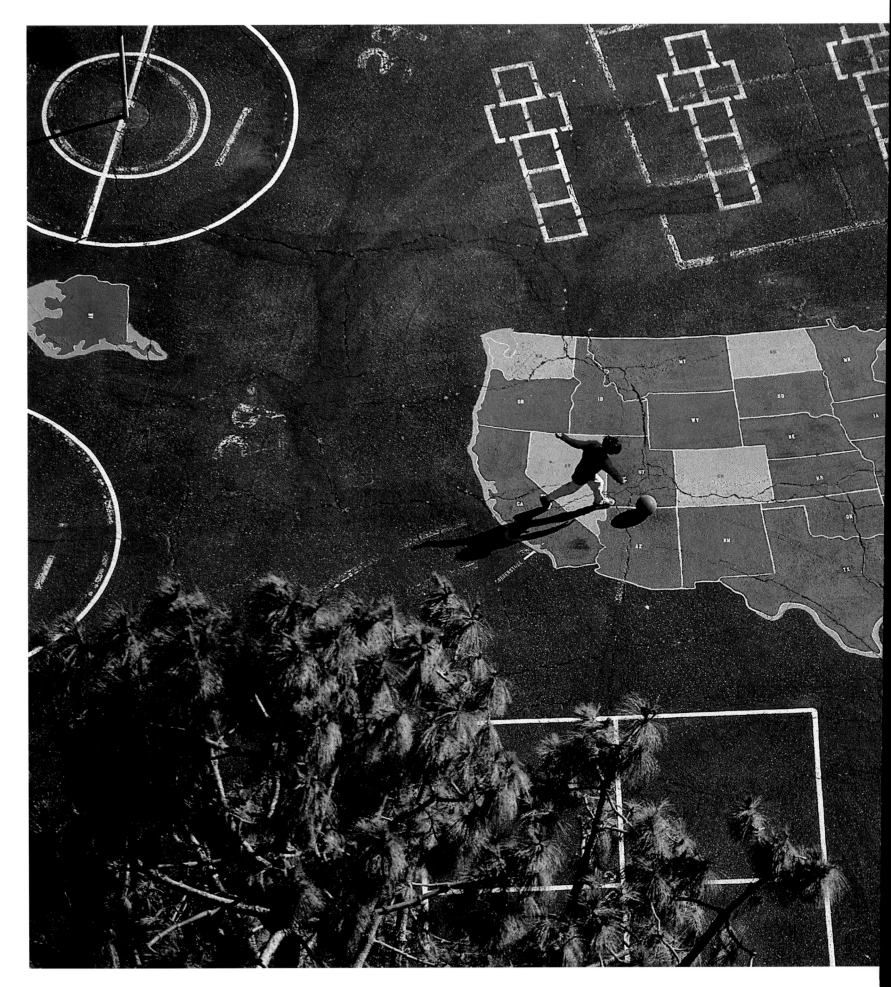

More people call California home than any other state.

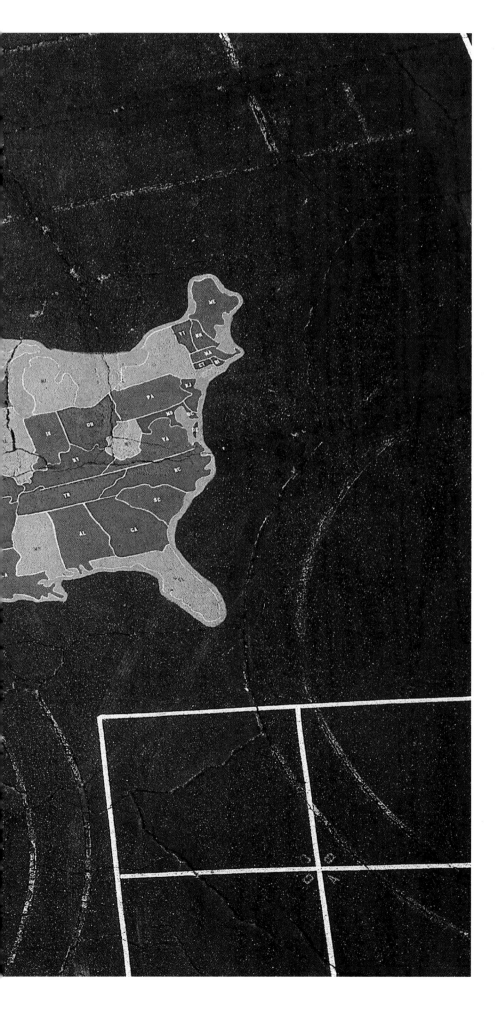

Can you travel from California to Maine in a minute or two? Well, you can if – like the child in the photograph – you merely have to kick a ball across a painted map! The child is exercising on one of the play spaces in a large school playground in Los Angeles, California. Like most playgrounds, it contains a variety of things to do. We can see markings for hopscotch and other games.

California is one of fifty states. But there is one that would require a long jump to get to from the main map. There it is, in the far left of the photograph: Alaska. And another state can't even be seen here (maybe it's hidden under the evergreen tree). Yes, aloha! It's Hawaii.

An obelisk in the desert

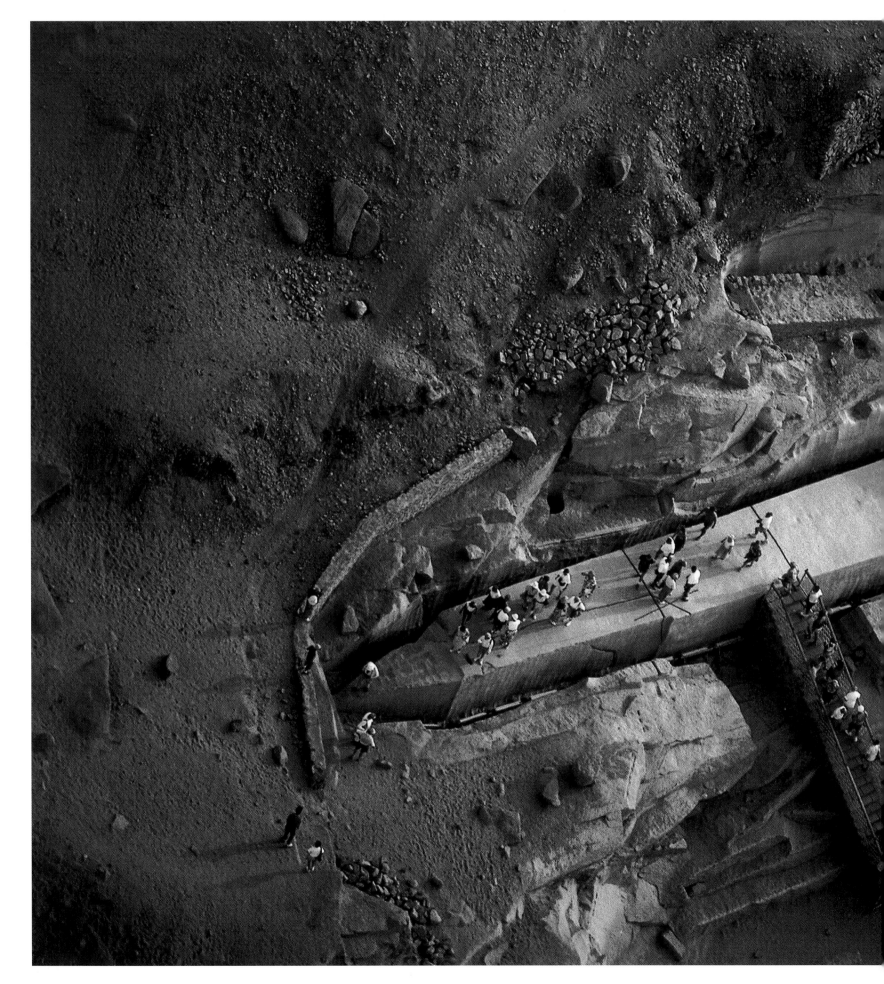

Egypt is located on the northern edge of the African continent.

It may look as if groups of people are climbing aboard the deck of a stone ship. But these people are climbing on and walking across the surface of an obelisk that was left unfinished many centuries ago. An obelisk is a tall stone column that can be seen for miles and that gives great importance to the place where it stands.

But this obelisk has never been raised. Why? Look down, at the sides of the great stone. They are grooved, as if they've been sliced with a giant serrated knife. Ancient people made obelisks by first marking the shape in rock, then digging small holes along its sides. The holes were filled with brushwood (little broken branches), which was drenched with water. The wood absorbed the water, swelled up and made the stone crack to form the obelisk's edges. It is an amazing example of human ingenuity.

There was a problem, however, with this obelisk. As it was being made, it cracked. You can see the faint crack running down from near the top and the two sharper cracks running from side to side. Therefore, this obelisk was left in its 'birthplace', to be viewed by tourists centuries and worlds away.

A whale's tale

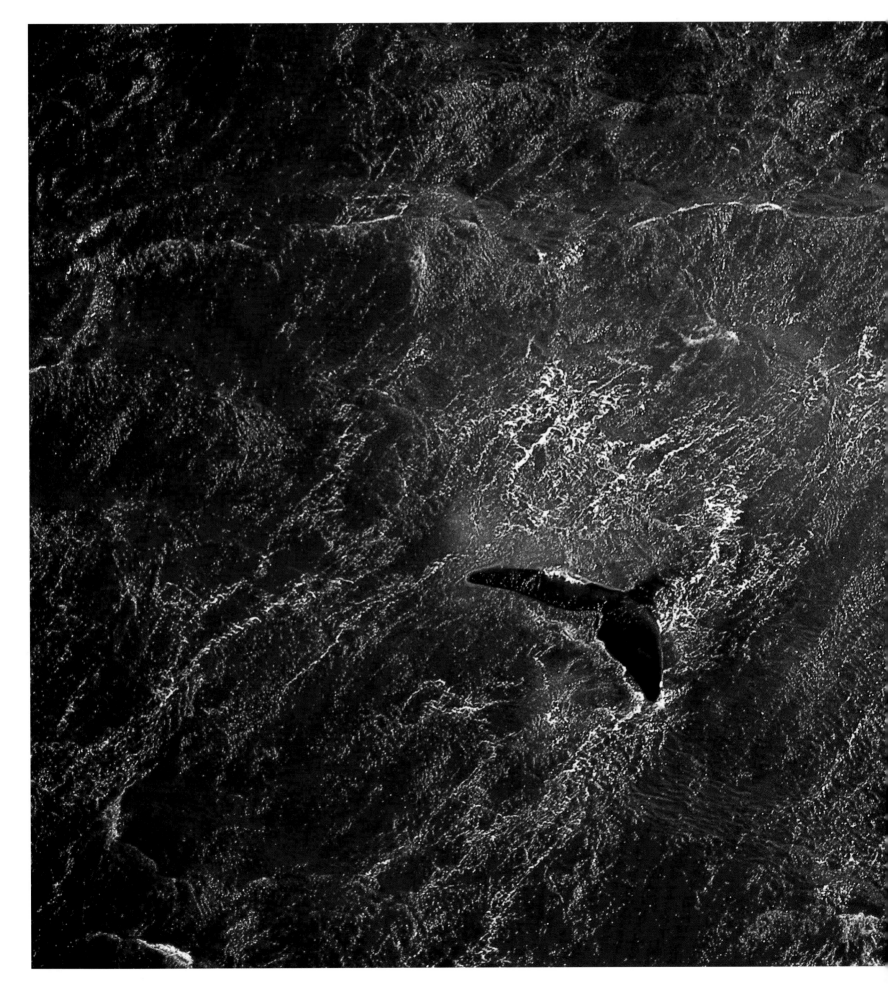

Argentina, along with its next-door neighbour Chile, is located in the southernmost part of South America.

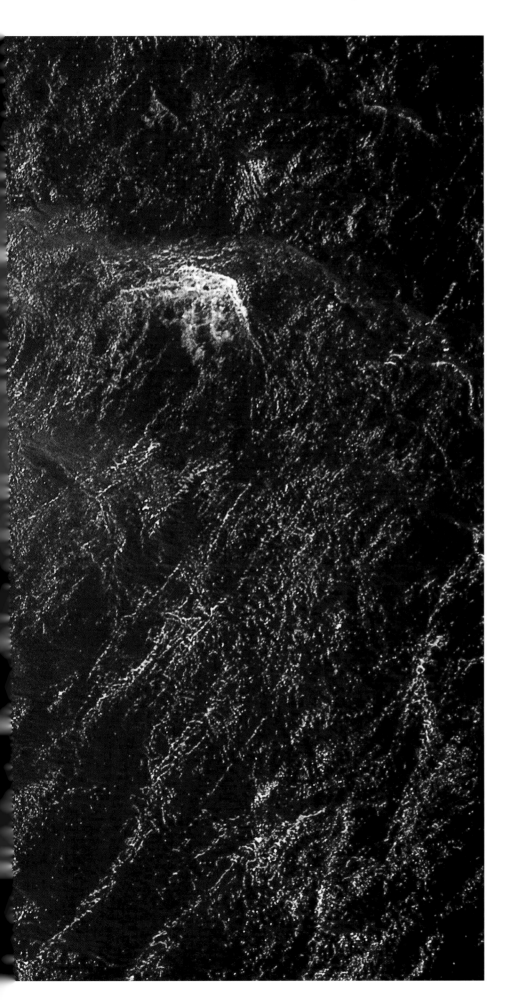

Now you see it, now you don't. The black shape in the rolling waters of the ocean may look like giant bird wings. But it's actually the rear, or caudal, fins of a huge whale, flailing its 'tail' as it dives into the depths.

The whale came up in the first place because whales are mammals, not fish – and mammals need air. Rising up with great force, the whale emerges into the air, jetting water from its spout. Then, in the same motion, it curves its great body and plunges back under. The last sign of it is the fins, or flukes, slapping against the water as the animal disappears.

This whale was photographed in the Valdes Peninsula off the coast of Argentina. But the whale won't remain here. Whales travel south to north and back again, following the currents and feeding on very tiny sea creatures called plankton. Wherever they go, whales must be on the lookout for their worst enemy: human beings. People still hunt and kill whales for the oil in their bodies. The whale in this picture has good reason to keep out of sight.

Bright vats of dye

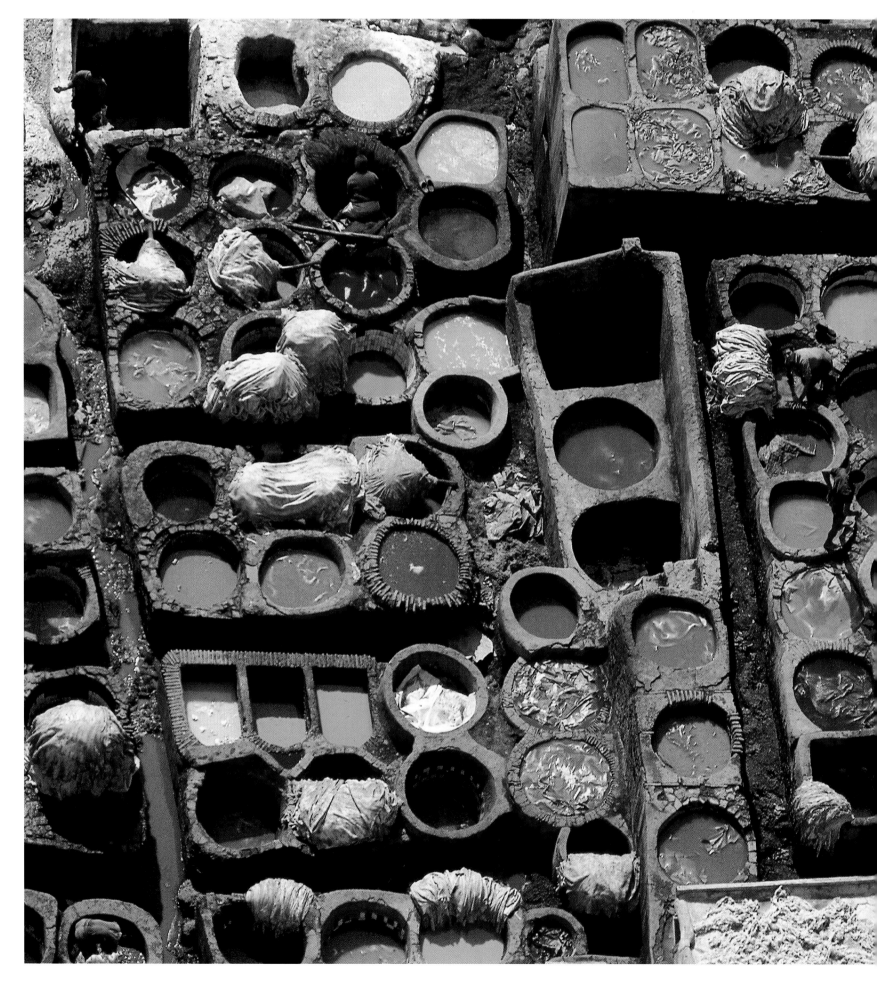

Moroccan artisans have a long tradition of making colourful cloth and leather.

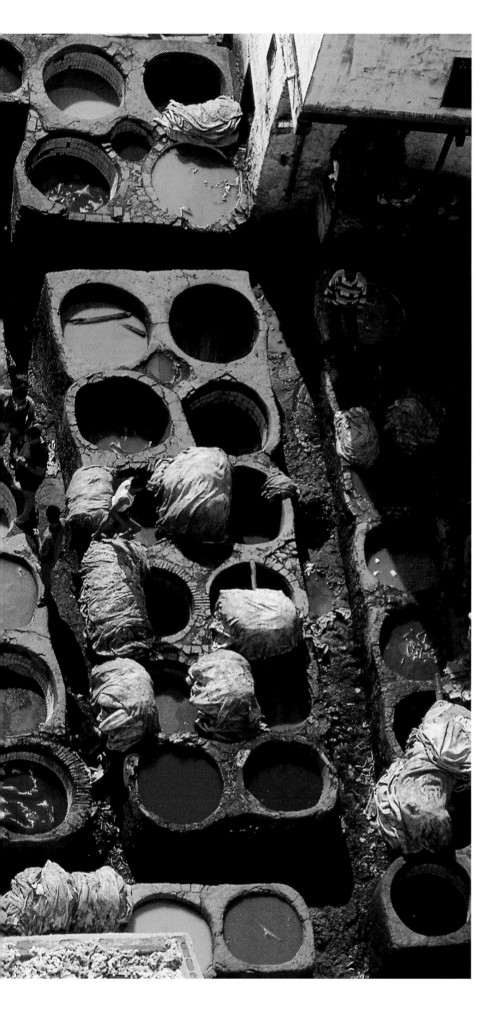

Are we looking at a close-up of a painter's palette? No, but this photograph does have a story to tell about colour. See the people? They are climbing around the edges of huge ceramic vats. Each vat is filled, not with paint, but with dye.

Dyes have a long history. Even in prehistoric times, people used them to give colour to their cave wall drawings. Many dyes come from plants. Red dye, for example, comes from poppies; blue dye from indigo; and beige dye from date seeds. Other dyes come from minerals. Black dye comes from antimony, which is found in the ore stibnite.

The workers here in Fez dye skeins of wool, cotton threads and tanned hides. (Some of these are in bundles at the vats' edges.) The workers stir and soak the various materials in the vats until they are completely saturated. Then, when the materials dry, they will be used to make the colourful rugs, shirts, cushions and slippers that you might see in a shop near home.

A vineyard by a volcano

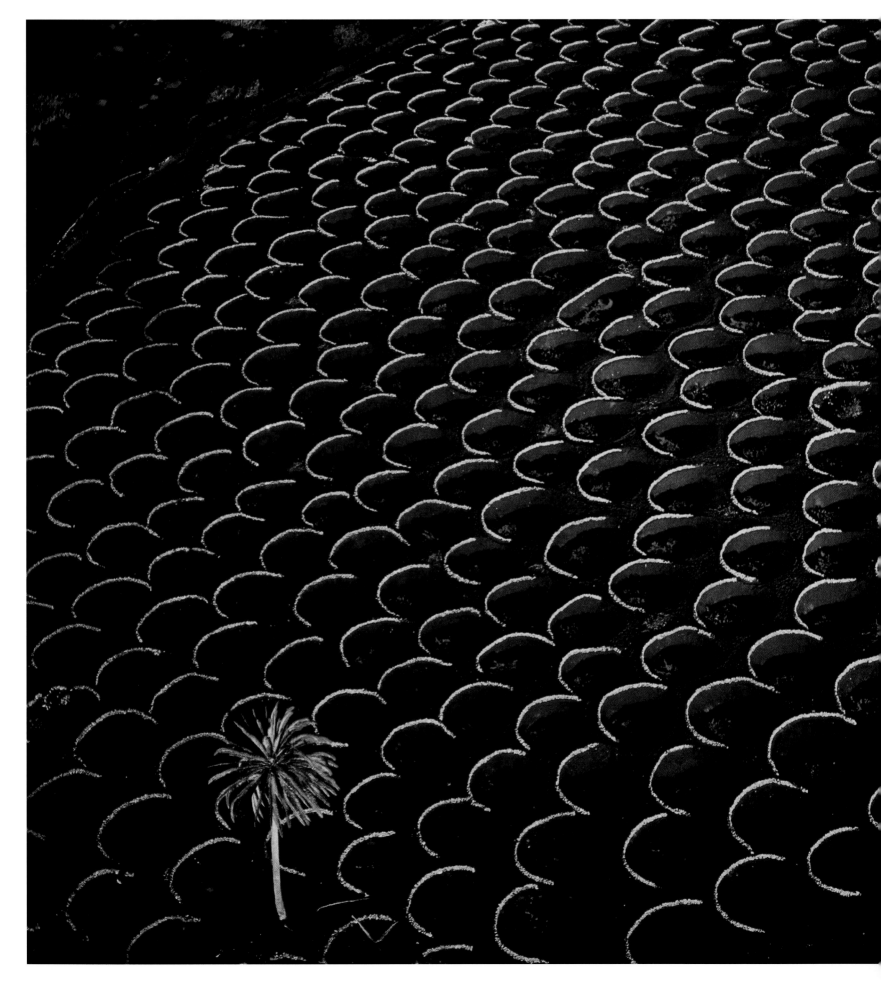

The Canary Islands are a group of islands off the northwest coast of Africa.

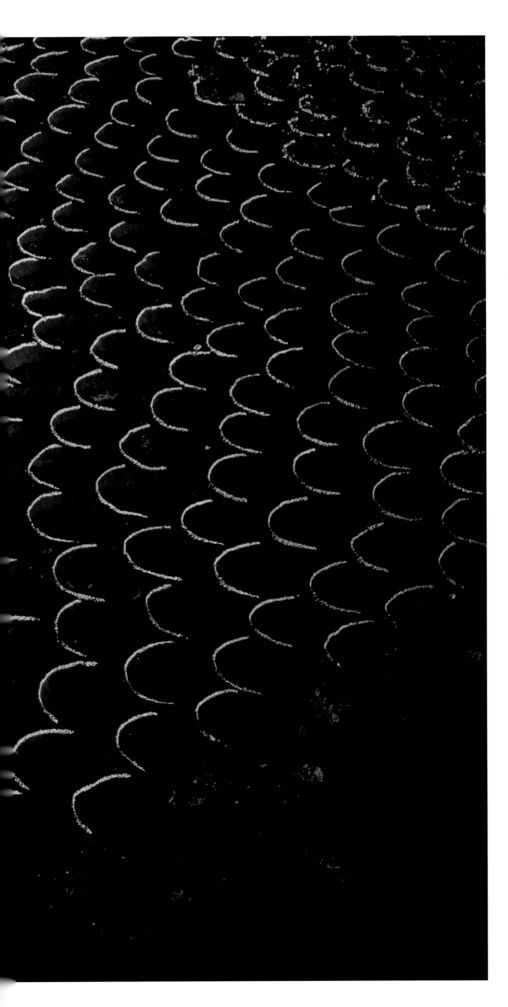

The sun sets over the Canary Islands, lighting up a single palm tree – and also what at first looks to be a huge collection of semicircles. But the circles are really small walls built up and around grapevines.

The Canary Islands, part of Spain, lie off the coast of Africa. The islands are mountainous and, in places, filled with volcanic ash and cooled lava. But strange as it may seem, these materials contain chemical substances that help many plants grow. This, combined with the warm climate, makes the Canaries an excellent place to grow certain grapes to make wine.

And so the farmers of the Canaries dig out small basins, which hold water more easily, and erect the tiny walls you see lit up in the photograph. The walls keep the dry winds from harming the grapes. But for now, before the vines have started to grow, they decorate the desolate hillside.

Fishing on a ghostly lake

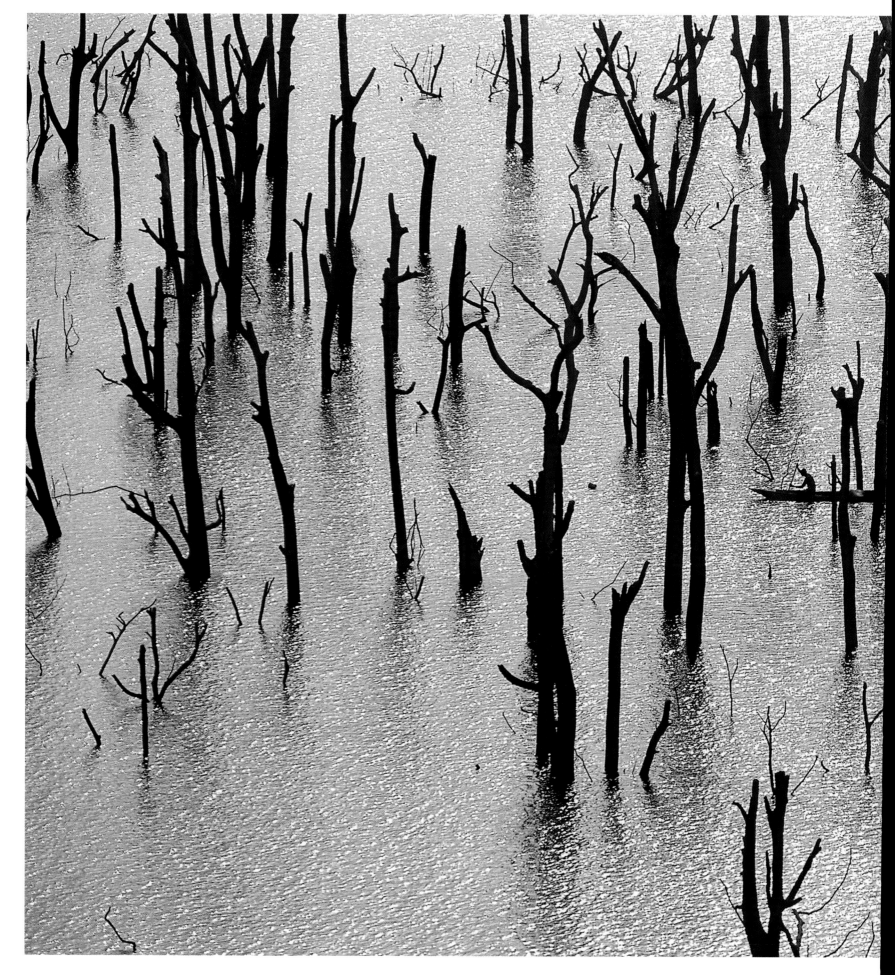

Côte d'Ivoire (Ivory Coast), in West Africa, has had to make difficult decisions affecting the land and the people who live there.

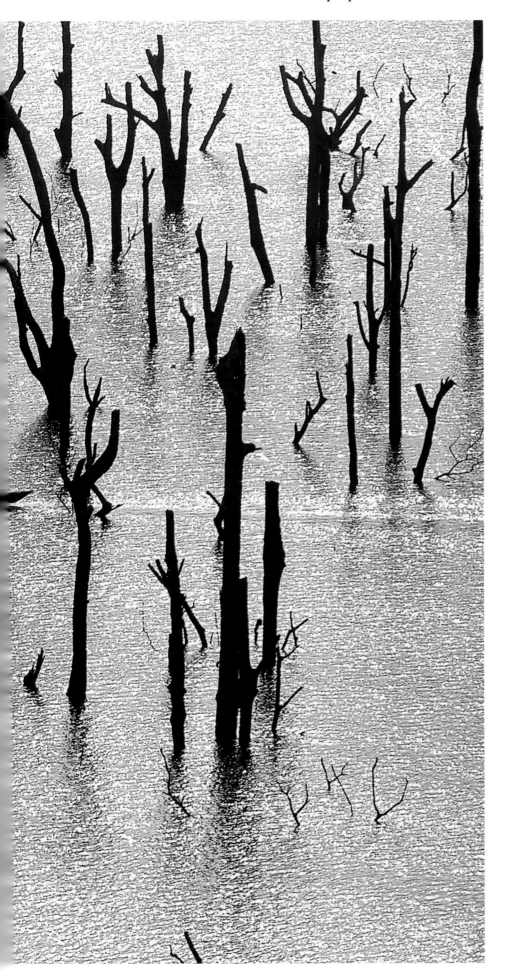

A ghostly silence fills the air. Dead trees stand like leafless sentinels over the still, slow-moving water. Only one figure moves through the deathlike scene. This fisherman, in a narrow canoe, crosses a lake that was, only a little while ago, a fertile field.

There was a flood here. But humans, not nature, caused it. In order to regulate the flooding of the Bandama River, located in Côte d'Ivoire, and also to construct a new hydroelectric dam, the Bandama was blocked. This caused the downstream-flowing water to back up, overrun its banks and spread out. The result is what you see in the photograph – an artificial lake, named Lake Kossou.

The land that the new lake covers was once farmland. Two hundred villages and tens of thousands of people had to move. The vegetation was submerged, leaving only these dark, dying trees to remind us of what once was here. The lake's water will help supply the new dam, which in turn will bring electricity to many people. But what of those who were forced to move? Is this progress? Was the trade-off worth it? It isn't easy to say.

Harvesting salt from marshes

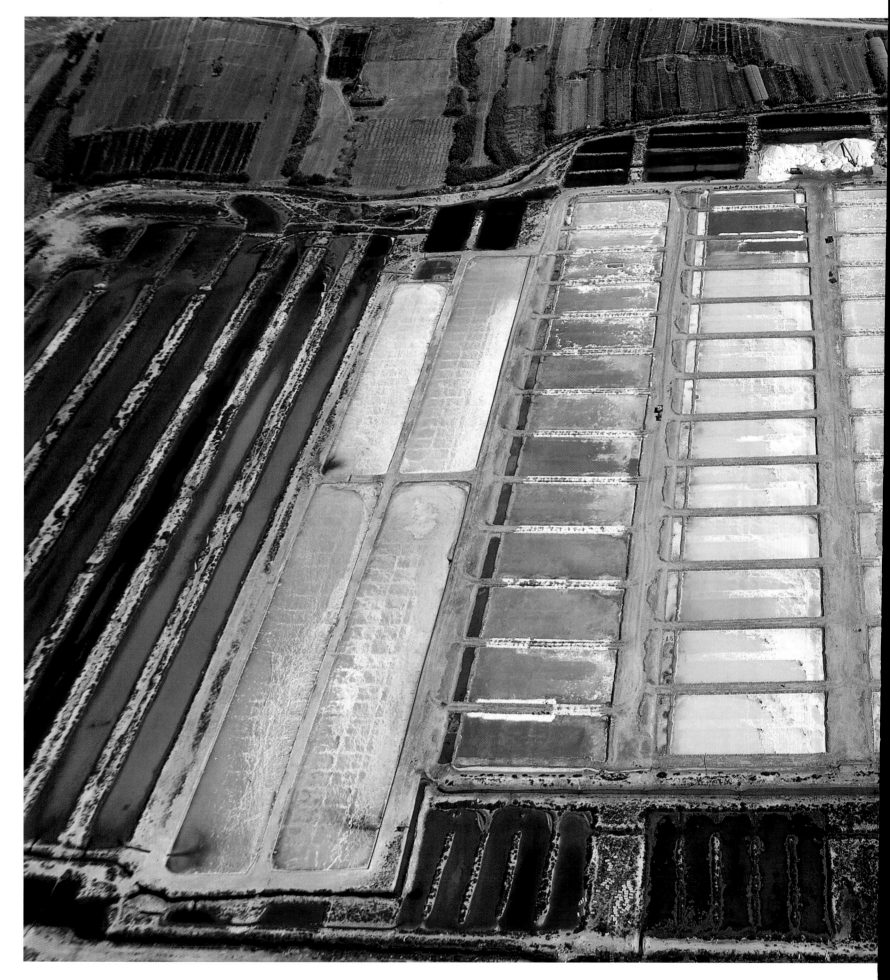

Morocco, an independent country located in the northwest corner of Africa, was once a colony of France.

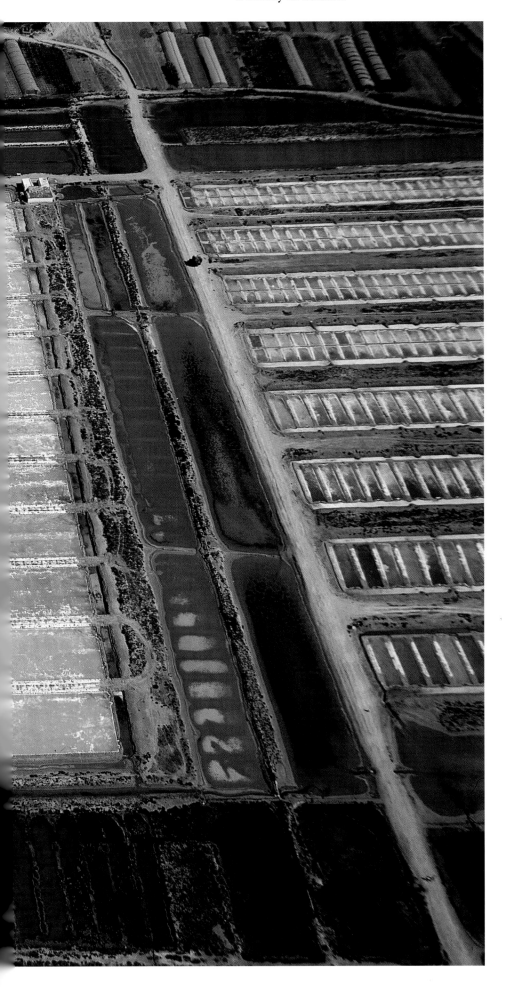

From above, it looks like a beautiful abstract painting whose many blocks of vibrant colour shimmer toward the sky. In fact, though, we're looking down at a complicated system of reservoirs of seawater – reservoirs used for harvesting salt.

How do you harvest salt? It doesn't grow in the ground like a plant. But sometimes it is separated from the water in which it is found. Here, in Oualidia, Morocco, reservoirs are dug out to collect the salt water that comes in at high tide. Slowly the water evaporates, and the bit that is left is even saltier. This salty water is allowed to pass from reservoir to reservoir. (Each rectangle in the photograph is a reservoir, and the sun shining down on the water is what causes the beautiful colours.)

At the top of the photograph is a huge pile of pure white salt. This is the end of the process – or almost the end. The real end is when the salt, so necessary and so useful to people and animals, reaches its final destination. That's when you pick up a salt cellar and add that extra touch to the dinner you're about to eat!

A farmer in Crete

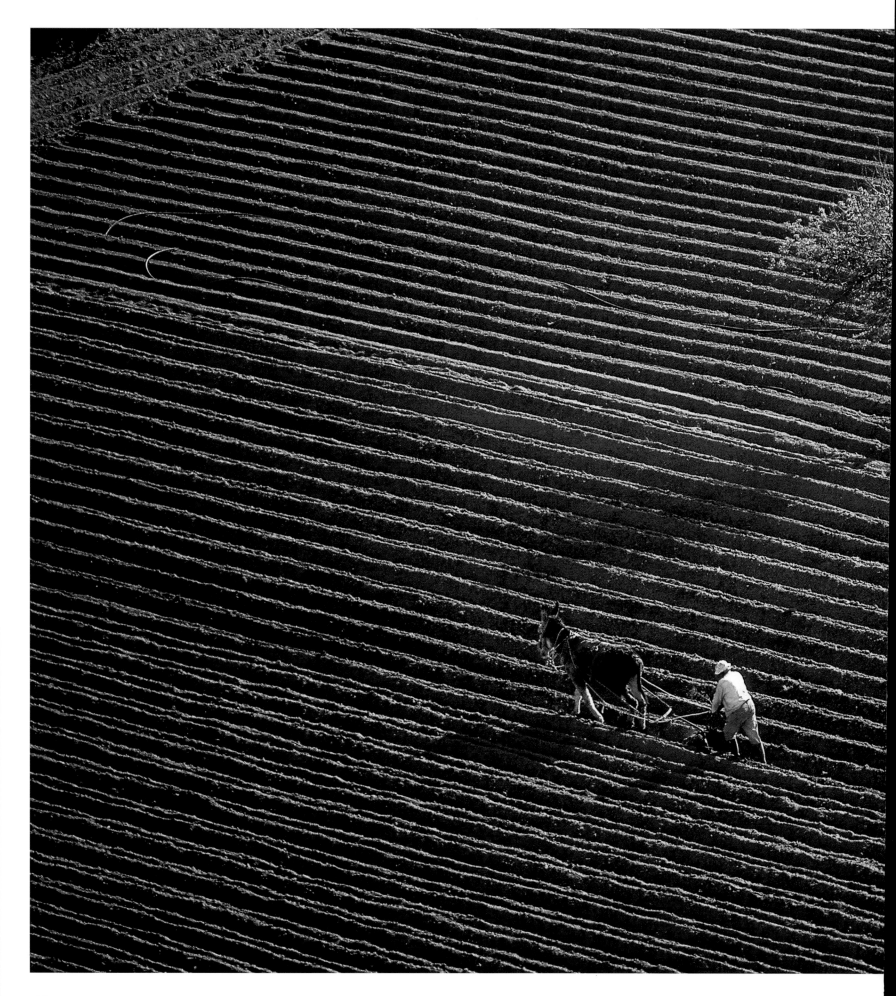

Crete is a Greek island located in the Mediterranean Sea off southern Europe.

Back and forth, back and forth, back and forth. And always keeping the rows perfectly straight. A farmer in Crete, a Greek island, is tilling his field, just as his father and his father's father did before him. He ploughs the earth in furrows, tossing up the underneath soil to aerate it, giving it fresh air to help add needed minerals.

In many parts of the world, farming is still done with few, if any, machines. A donkey pulls the simple plough, urged on by the farmer, who prepares himself for the hot, dirty work by wearing high boots and a hat that protects him from the sun. But the man protects his donkey, too. Do you see the green branch in the farmer's hand? He is carrying it to chase away the flies that pester the animal.

The field is clear. And yet, in its very centre, a lone tree grows. Long ago, some farmers kept a tree in their field because they thought it brought good luck, perhaps by being a home for friendly spirits. This farmer, however, keeps his tree because it has grown for years and years – a kind of good memory of his ancestors who ploughed here long ago.

Drying dates in a palm grove

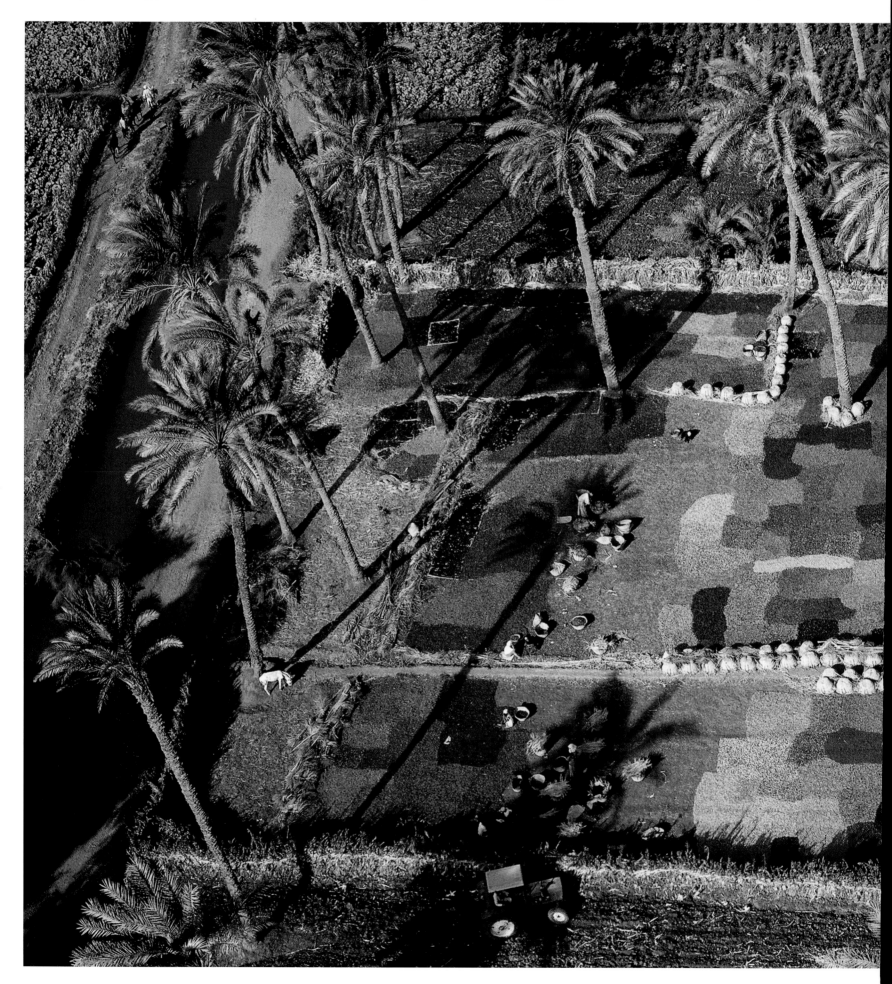

The climate in some parts of Egypt is good for growing dates and other food.

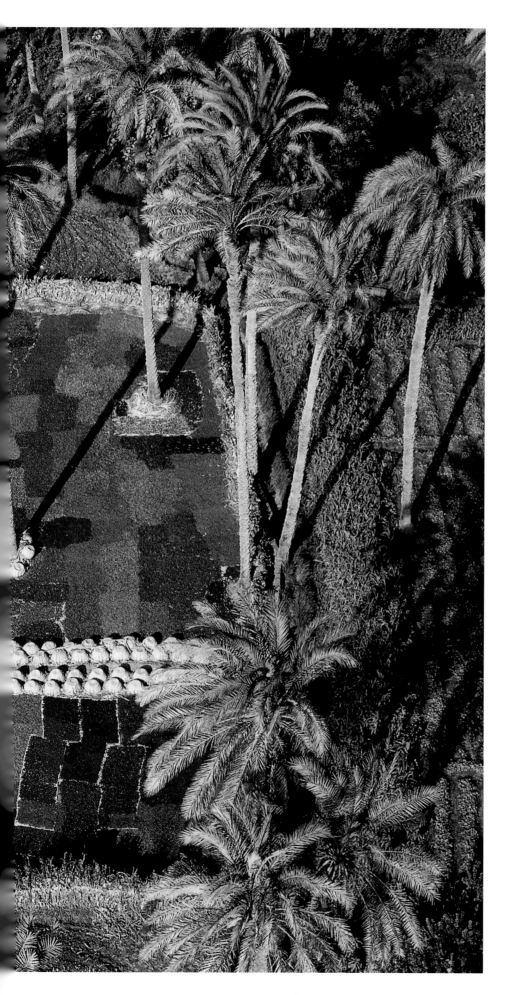

This looks almost like a map of a very orderly brown world. But it is really a carefully organized collection of dates.

Look closely at the tops of the tree trunks. The golden clusters hanging there are dates, almost ready to be harvested. The harvester is a very agile young boy who climbs up the tree's trunk and, day after day, brings down the dates.

Then the family sorts the dates (you can see two people doing this on the left side of the photograph). The dates are spread out to dry in the sun. And what about the many-coloured patterns? They are caused by the different colours of the dates. The colours, from gold to yellow to red to brown, tell the date growers which ones are ripe and ready for the market.

Selling fish in an open-air market

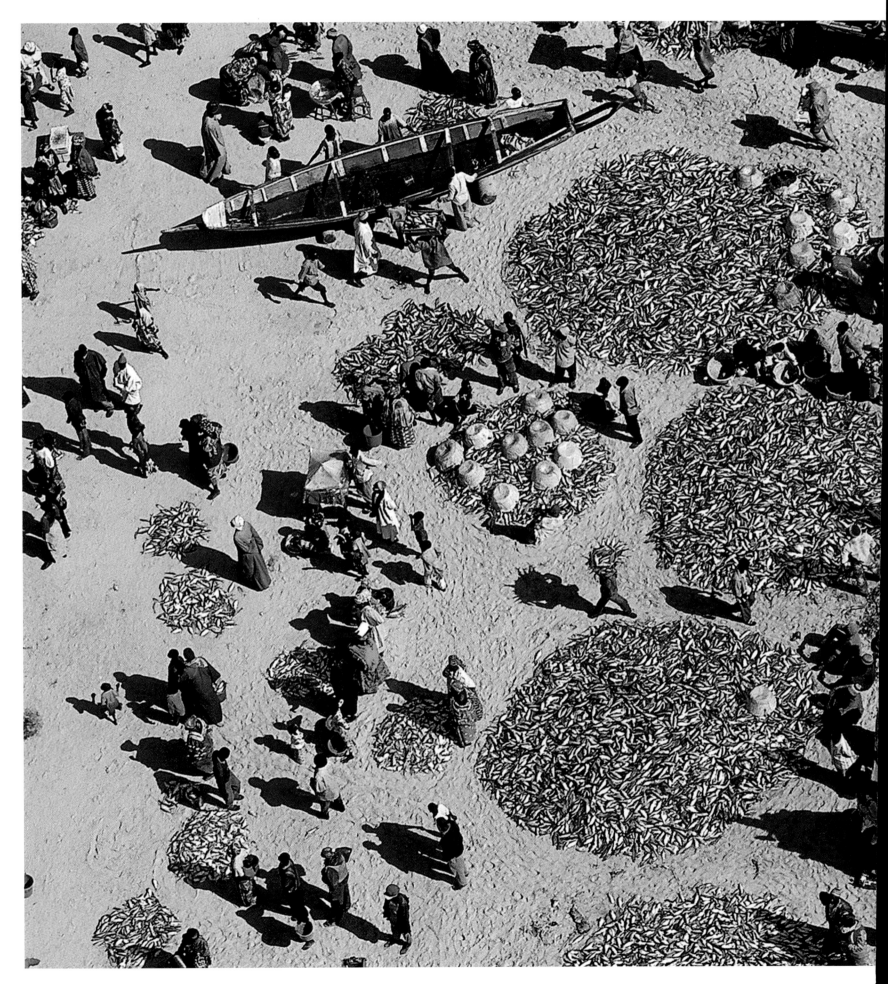

Senegal, whose capital is Dakar, is located on the west coast of Africa.

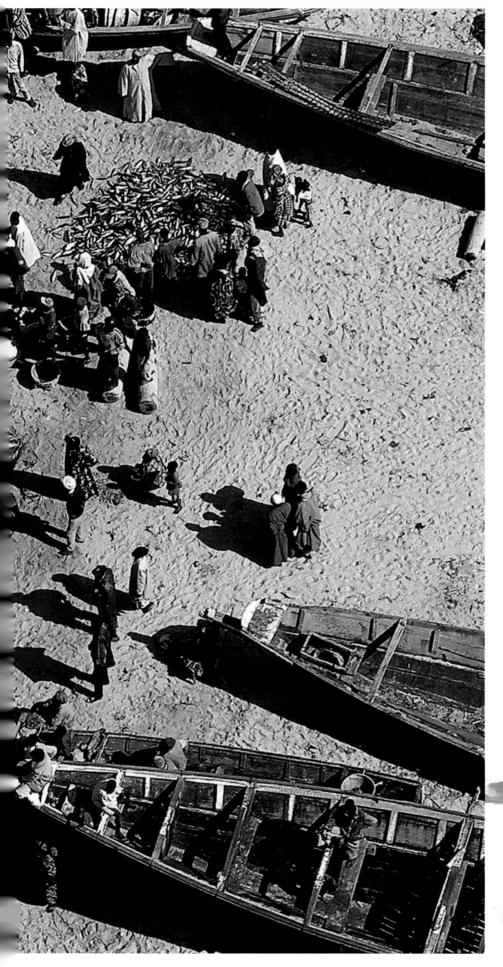

It's early morning. The boats have come in, and the night's catch is being set out. Here in Senegal, the sandy beach of the coast itself is the marketplace. During the long night, the fishermen have netted and hooked hundreds and hundreds of fish – sardines, hake and tuna – and now it is all for sale.

Even before the narrow boats came ashore, the fishermen were busy sorting their catch. The piles are organized by species and size of fish. Deep wicker baskets were used to unload them. Now the baskets have here and there been turned upside down on the fish piles, like rickety umbrellas that protect the catch from the hot sun.

More and more buyers have entered the marketplace. Of course, there are no shelves or counters here. And how much does the fish cost? That always remains to be decided. In this open market free-for-all, buyers and sellers compare, bargain and haggle, until they finally settle on a price.

53

A hot spring in Yellowstone

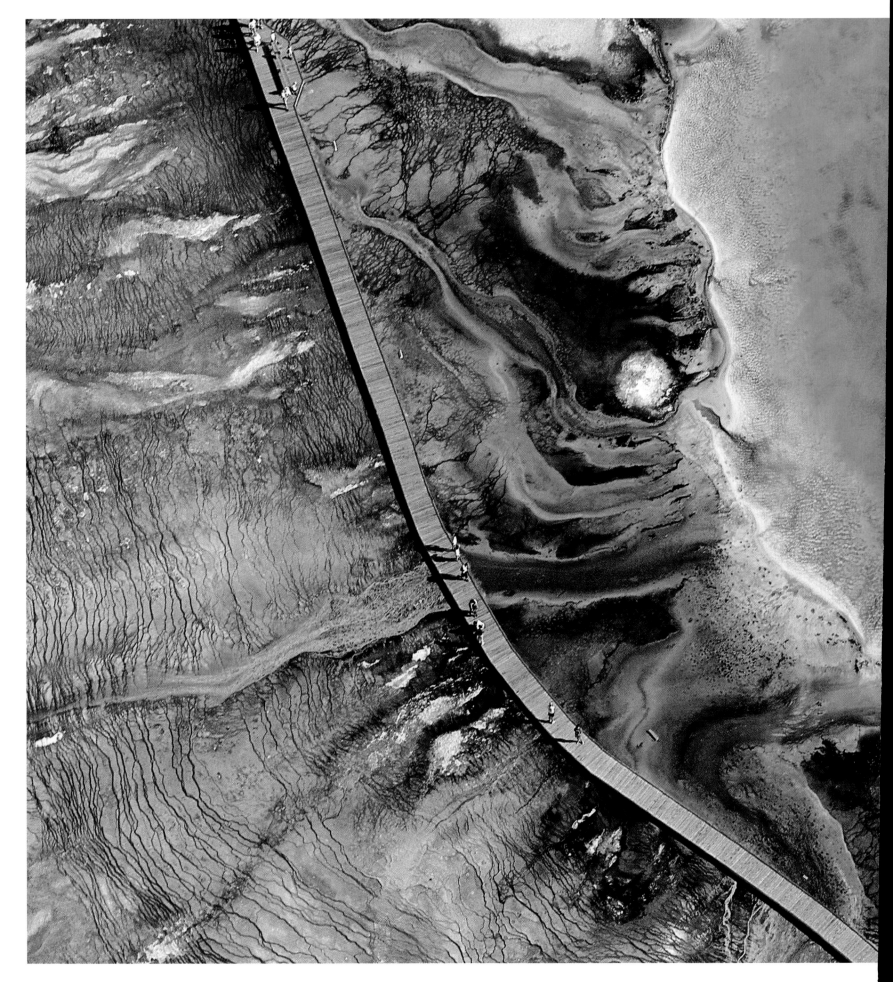

Yellowstone National Park, in the western part of the United States, is one of the nation's most famous and beloved national treasures.

The colours are so strange, you might think that this is a scene from a science fiction film. But you're looking down at a great natural wonder. This is the centre and outer edge of the Grand Prismatic Spring in Yellowstone National Park.

Far below, on a long grey walkway, you can also see tourists who are here to take in this amazing sight. Yellowstone, created in 1872, was one of the first national parks in the world dedicated to protecting untamed natural spaces. It contains more than three thousand active hot springs and geysers. Yellowstone lies on a volcanic plateau, whose underground heat forces the hot gas and water to erupt into the air.

Why the amazing colours? The Grand Prismatic Spring is large (more than 100 metres in diameter) and hot – well over 65 degrees Centigrade in some places. Some algae and even some colonies of bacteria can live in this forbidding water. These tiny plants and animals, mixing with the water itself, put on this colourful show.

Village life

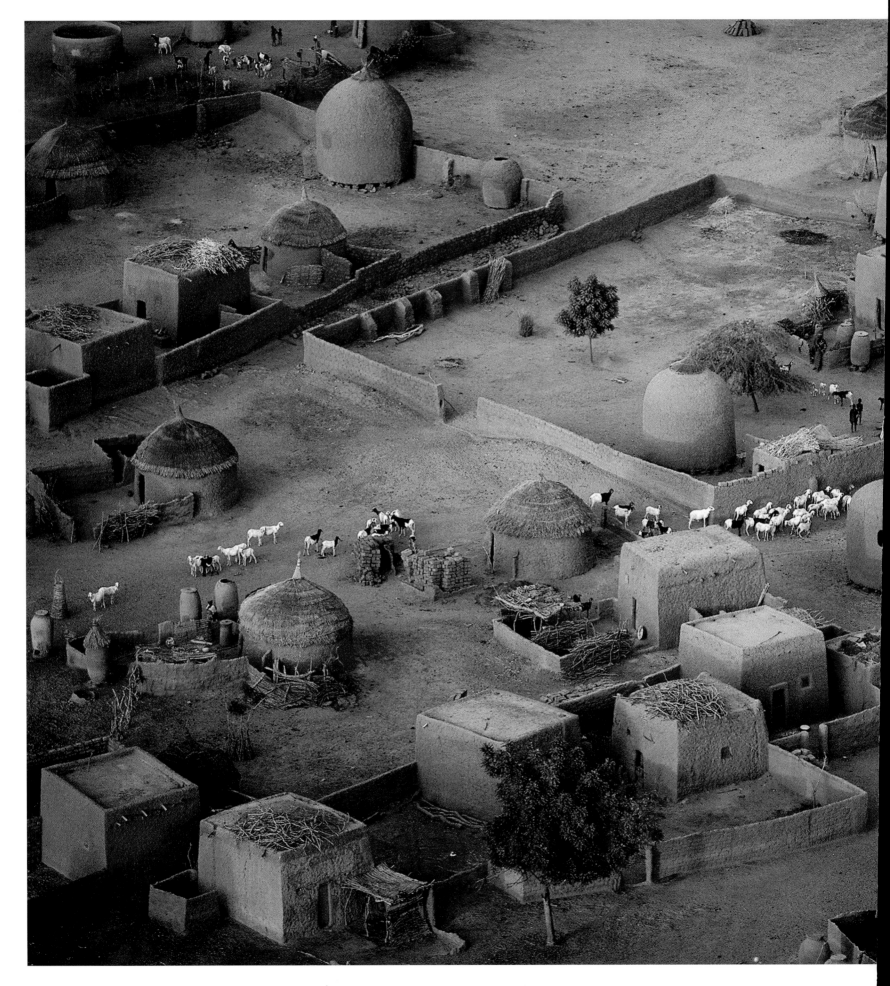

Niger, in northwest Africa, is a country populated by many different groups of people.

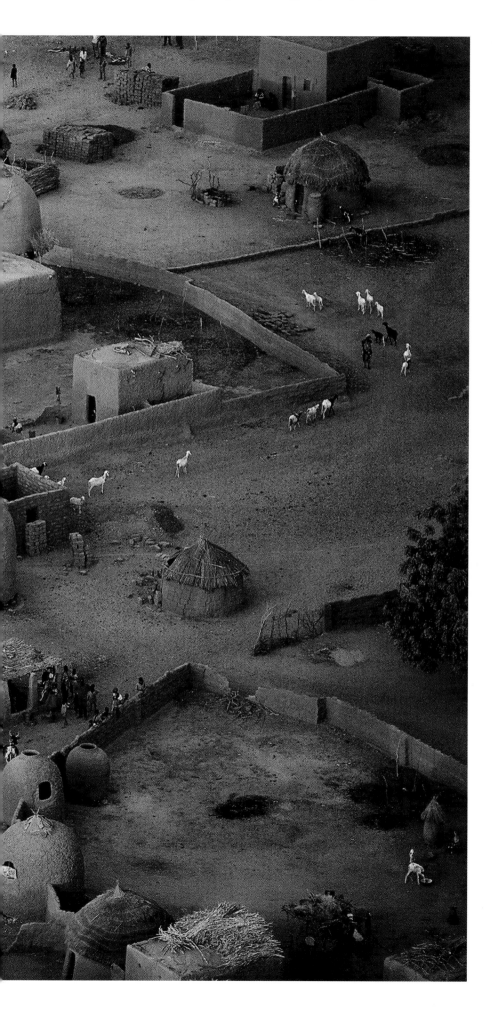

The houses are so neatly designed, and the landscape so flat and clean-looking, that this seems almost like a toy village. In fact, it's a real village in Niger – a village inhabited by the Hausa people. And along with the people, as you can see, there are lots and lots of goats. Why goats? Because goats (which produce milk and meat for the owners) are hardy animals that can endure harsh climates, thirst and hunger.

Two kinds of buildings – square and dome-shaped – are in the photograph. You can probably guess which kind the people live in; they have doors on one side. The dome-shaped buildings are used to store grain. Look at the very bottom of those buildings. They are raised up on wood for a good reason: to help keep out rodents and insects that might crawl in and eat the grain.

The Hausa people are well known for their efficient living systems and for the high quality of their craftwork. That's quite clear from the photograph. The solidly built structures are made of a mixture of earth and vegetal fibres. Even the flat roofs have a purpose – as places to store firewood. And the trim, bricklike walls that surround the dwellings have an important purpose, too. It's here, inside the walls, that the goats return, after browsing for food, for a good night's rest.

Moving crops on the Niger River

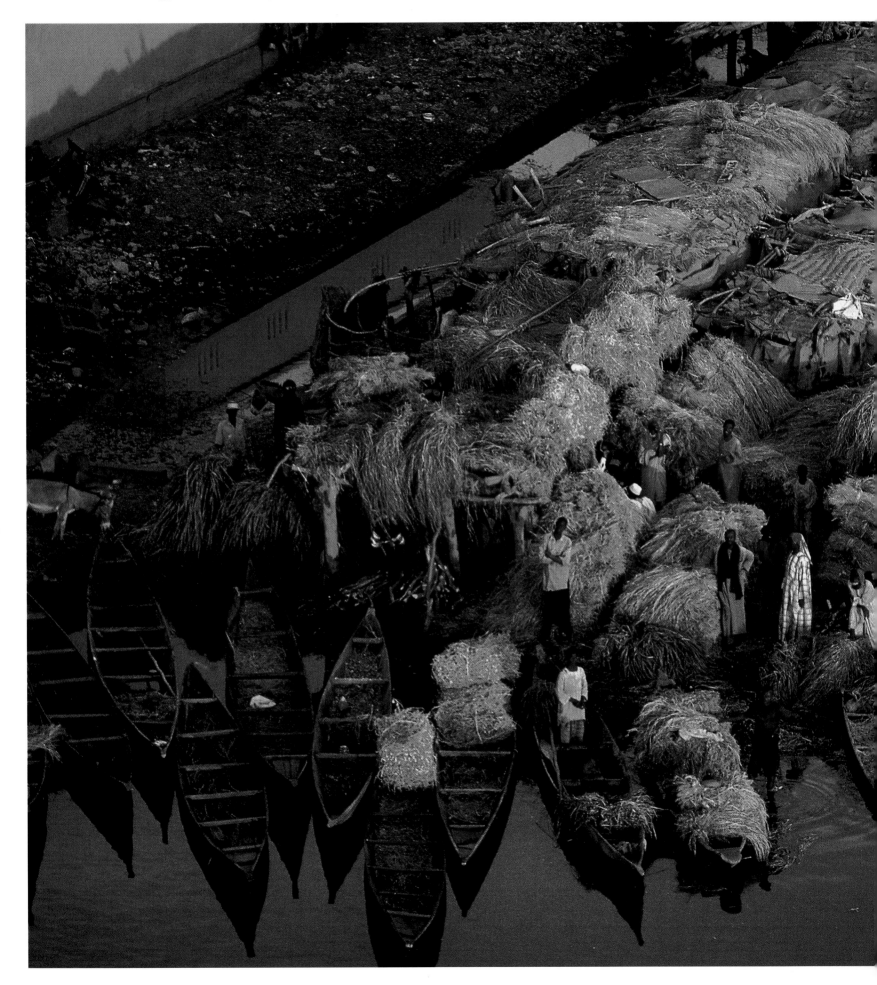

The people of Mali depend on the Niger River for transportation, food and water.

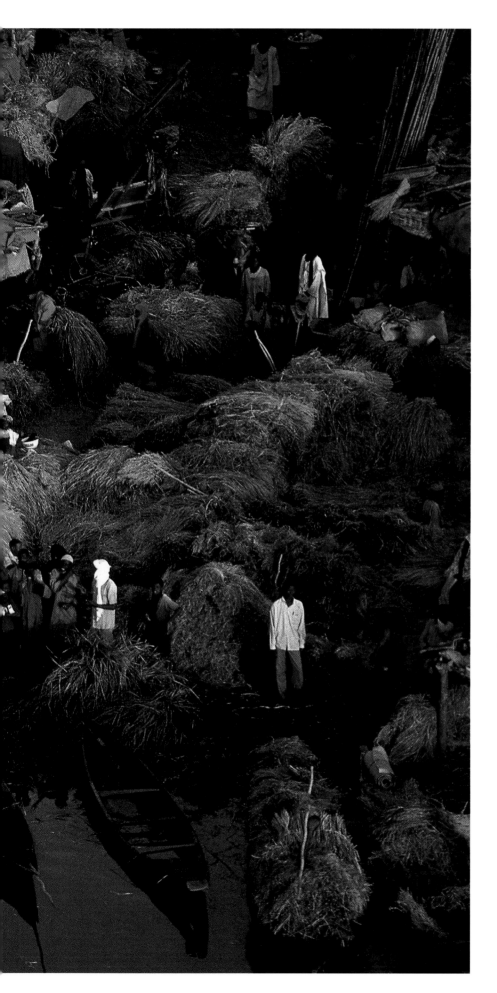

Judging by the deep shadows, it must be twilight or early morning. People are loading their flat-bottomed canoes by the shore of the Niger River. The boats (flat-bottomed because the river is shallow at certain times and in certain places) will bring goods to a marketplace many miles away.

In countries with few roads and not many vehicles, a river can become the main means of travelling long distances or transporting goods. This is the case in Mali. The Niger River connects Bamako, Mali's capital, to the important city of Gao, more than 600 miles to the north. Hundreds of people and many kinds of products travel down this great watery highway.

The boats are carrying golden brown bundles of bourgou, a plant that grows in the Niger River. The plant, used as fodder for livestock, is harvested from the river and brought to the docking area on carts. If you look carefully (try the left side of the photograph) you can find two of the donkeys that hauled the bourgou to this very place.

Playing field at Yankee Stadium

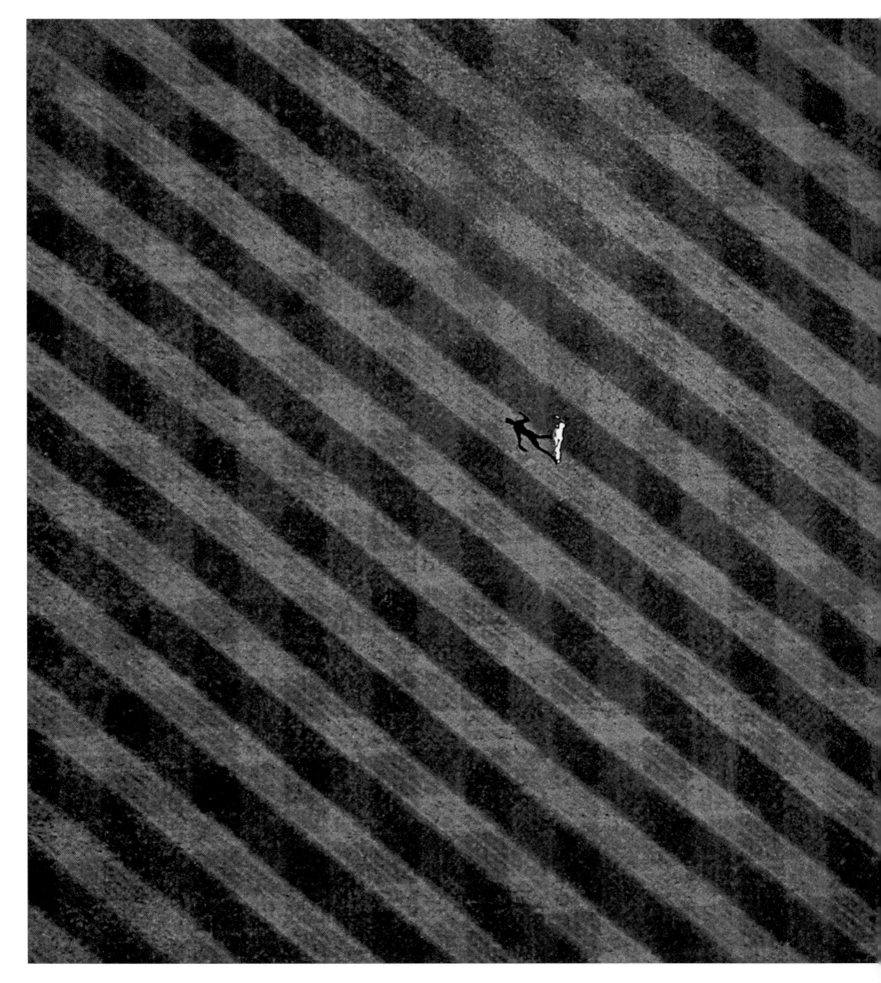

New York City, on the eastern coast of the United States, is home to several professional sports teams, including two baseball teams – the Yankees and the Mets.

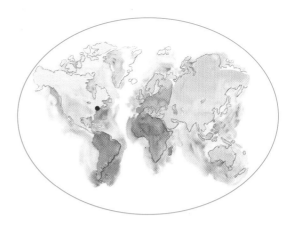

It might be a lone farmer standing in the middle of a perfectly sown field. It isn't a farmer, of course, but it is a field of a certain kind. The white-uniformed baseball player casting a long shadow is standing in the outfield of Yankee Stadium in New York – one of the most famous sports stadiums in the world.

Can you tell what the player is doing? From the shadow, we can see that his arm is cocked, ready to throw the ball to one of his teammates.

The line of darker and lighter green that stretches across the field reminds us that this is real grass. (It is the way the grass is cut that causes the two green shades.) More and more, professional sports fields around the world use artificial grass, but Yankee Stadium, home of the New York Yankees, remains true to the past.

Floating wood down the Amazon

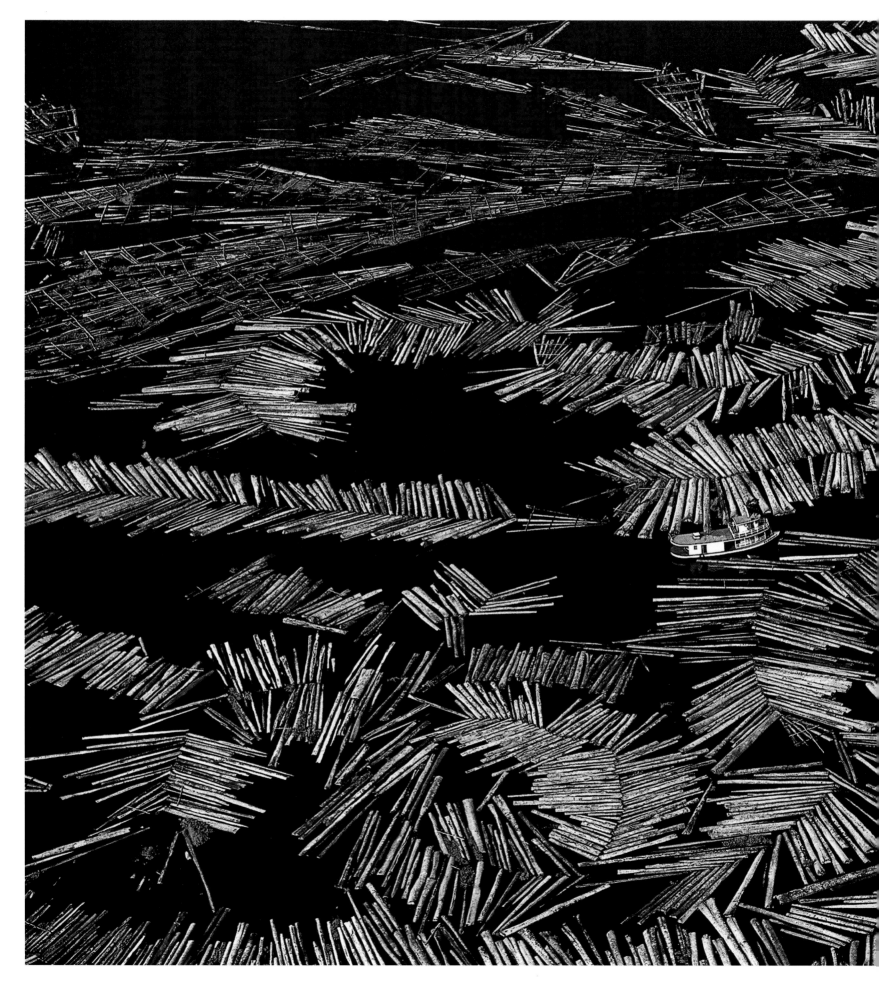

Brazil, located in the east of South America, is a vast country rich in natural resources.

At first they might look like matchsticks laid out in an odd, jumbled design on a black cloth. But then you see the boat. And you realize that these 'matchsticks' aren't matchsticks at all, but huge logs.

The logs, cut from nearby forests, are being transported on the Amazon River. Woodcutters haul them to the river's edge and secure the trunks together by many clamps and chains, arranging them in the 'frond' shape you see. This arrangement helps the logs float downstream in an orderly fashion – guided along, of course, by the green and white tugboat in the centre of this enormous 'herd'.

The logs are headed for paper pulp factories. But this useful end of the trees has another, negative, side to it. With more and more trees being cut down, the clearing of Brazil's great Amazon forests is causing climate changes around the world. And this, in time, is threatening many species of animals and plants. Here, as elsewhere, people must weigh the good results against the bad.

Erosion in the gorge

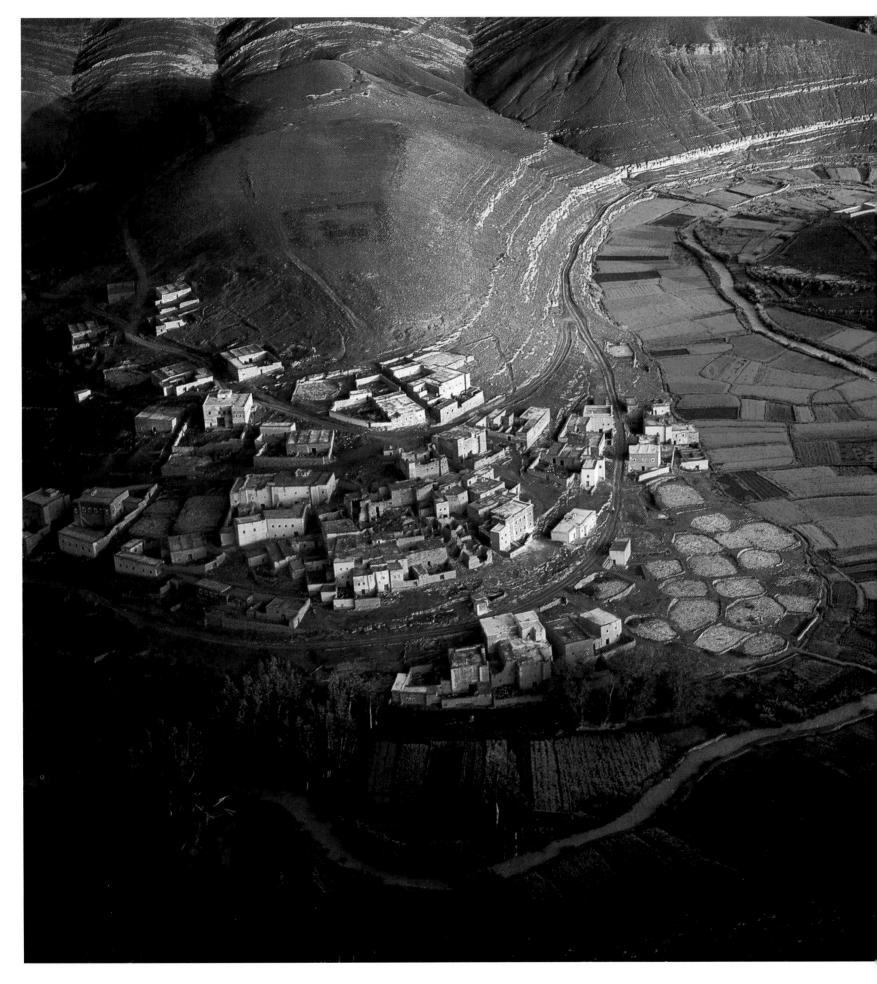

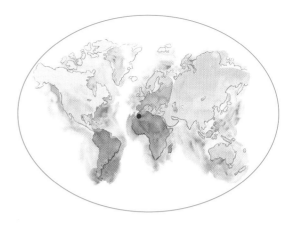

Morocco is a mostly dry country whose people carefully use the water resources they have.

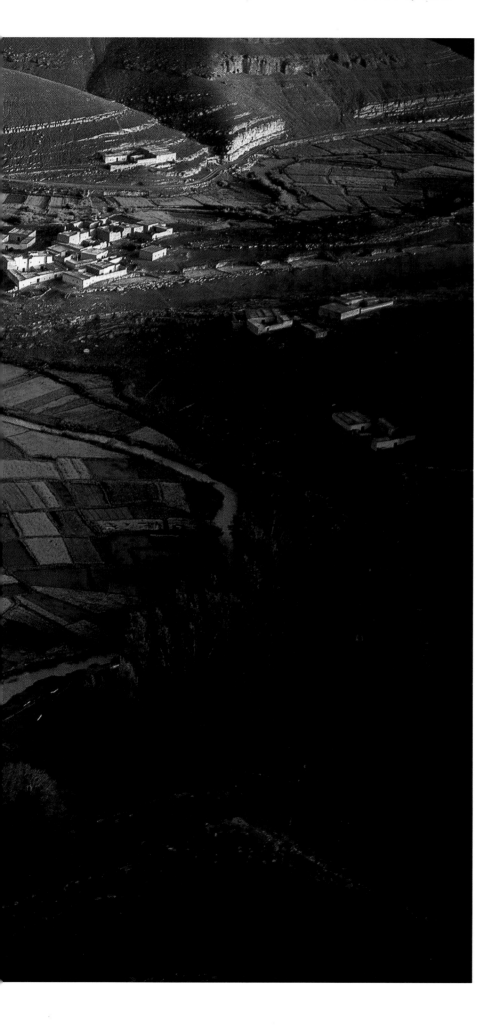

Some people, long ago, believed there was something godlike about a river. And in some ways, this photograph can help explain why. But first, can you find the Dades River as it winds its way through the landscape?

Next, look at the green parts of the picture. These are fields, and they are growing just where you'd expect: next to the water supply. Water from the river (either from flooding or due to thin human-made canals) has caused a small part of this dry landscape to bloom.

Everything follows the river. Do you see the narrow road that runs above but alongside it? It leads from one village to the next. This photograph shows so clearly why rivers dictate where people will live and crops will grow. If the river were not here, the fields and the road and the villages would not be here either.

This house is an island

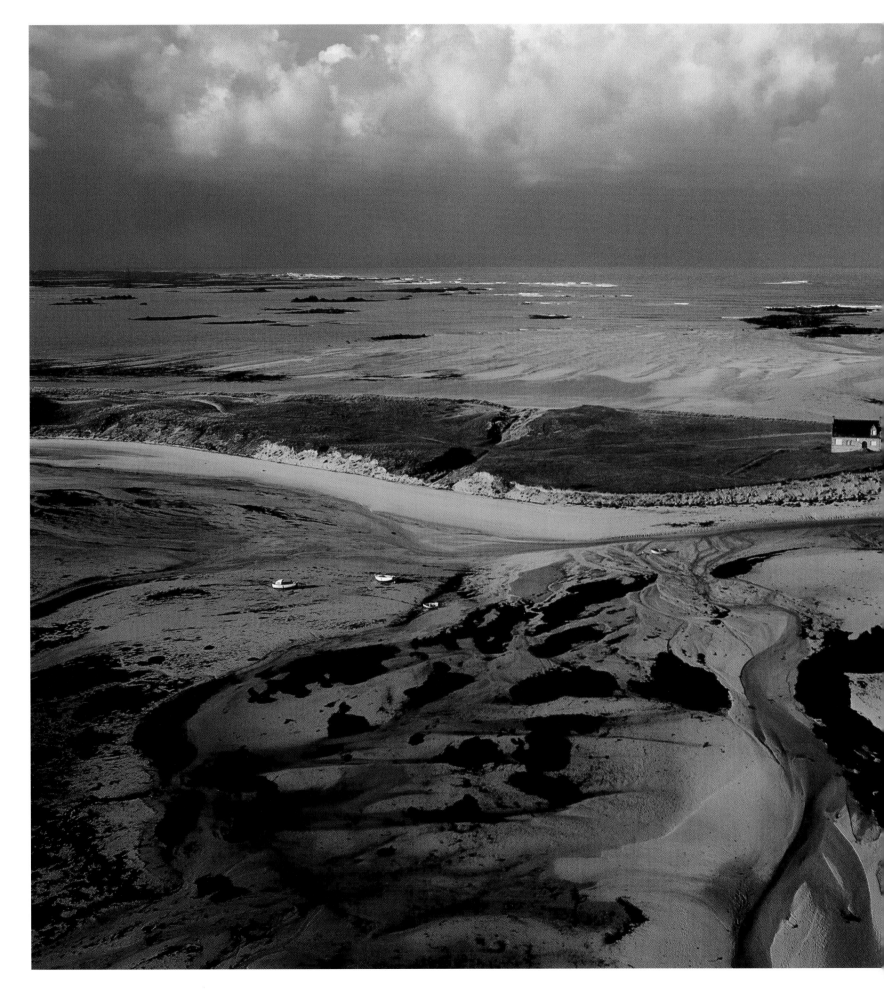

France, a country located in Western Europe, contains famous cities and beautiful coasts.

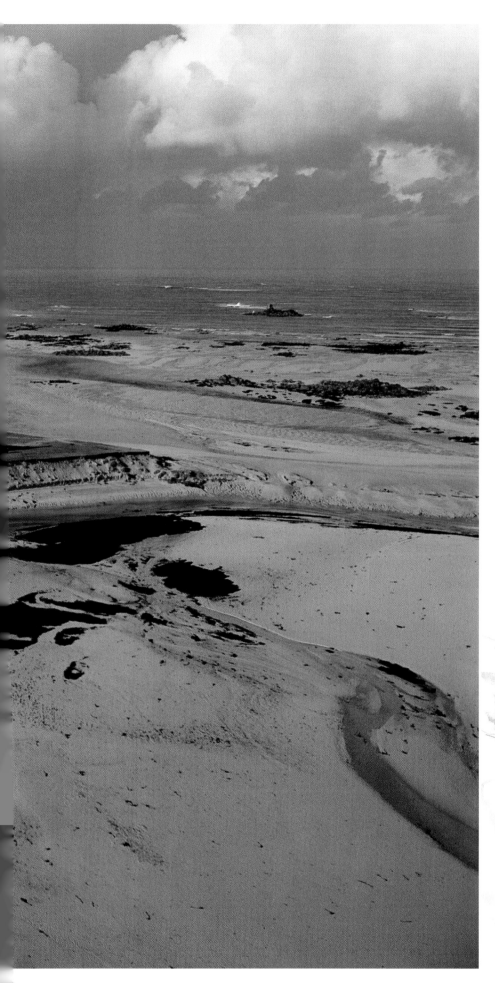

The winds blow, the waves crash and in the centre of it all sits one lone house. This is the rugged coast of Brittany, in northwest France. For many years people lived in this house. The surrounding shoreline changed radically every day from a huge sandy expanse at low tide, shown in this picture, to a narrow slip of land at high tide. You can see evidence in the picture that water has recently been here and left. Do you see the water marks and the boats high on the damp sand?

This little *ker* (the local word for 'house') was built in 1953, on a narrow spit of land extending into the Atlantic Ocean. But ocean winds and the rise and fall of 8-metre tides eroded the land around the house. In 1983, this *ker* was 45 metres inland. By 1999, wind and water had worn away the cliff so that the house was just 2 metres from the edge! In 2000, the lonely house was demolished – before it could collapse into the sea.

Carpets for sale

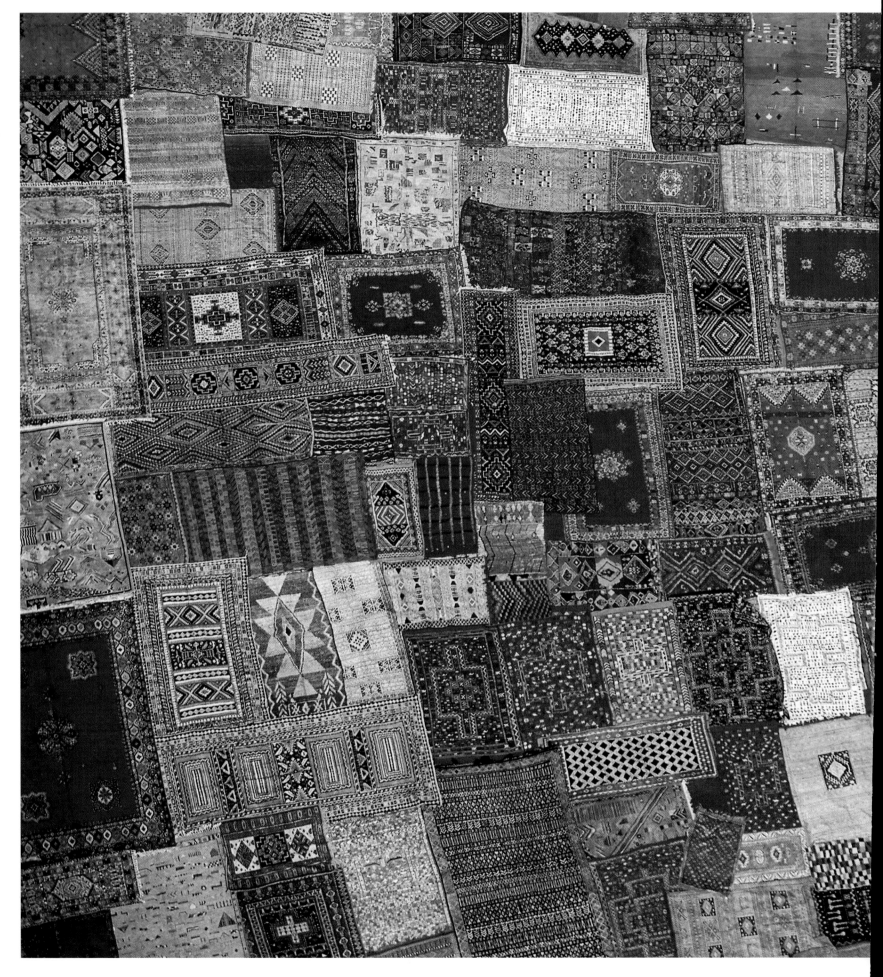

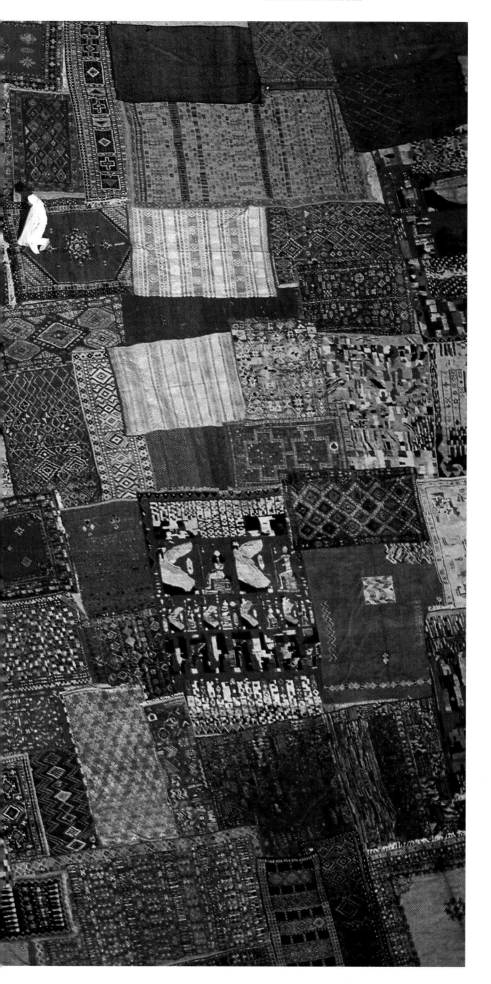

Colourful rugs are one of Morocco's most important exports. These ones are in Marrakesh.

Rugs, rugs and more rugs! They are everywhere you look, except in one place. Do you see the lone person bent over a rug, inspecting it? It's the white figure at the top centre of the photograph. The picture is filled with Moroccan rugs, and the person in white may well be one of the women (rug-making in Morocco is done exclusively by women) who designs and makes them.

The rug designs may look random, but they are not. The rug-makers carefully create their beautiful geometric motifs – motifs that are symbols of earthly paradise.

At one time, woollen rugs were thought to bring good fortune to the owner. Whether that is true or not, these rugs will have a long life. First they will decorate the floors of houses. Later, worn thin by thousands of passing feet, the fragments will be used by horsemen as saddle rugs to protect the flanks of their horses.

The white horse

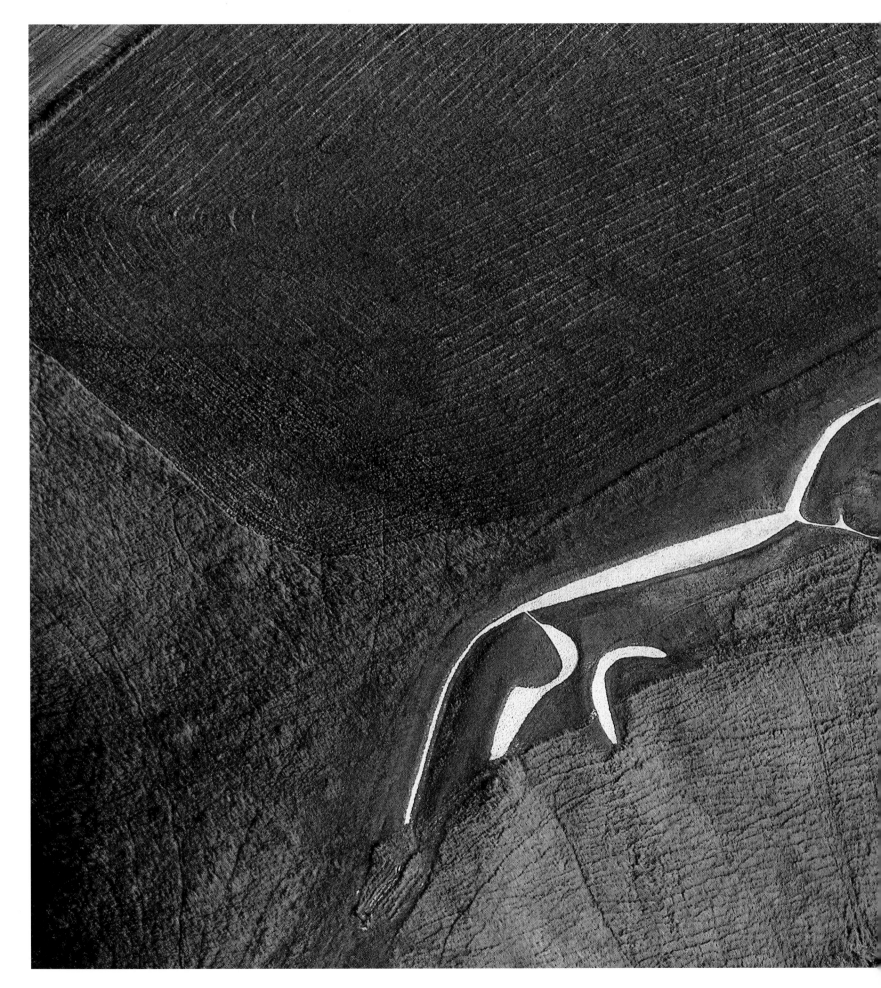

England, Wales, Scotland, Northern Ireland and some small islands around the coast make up the United Kingdom.

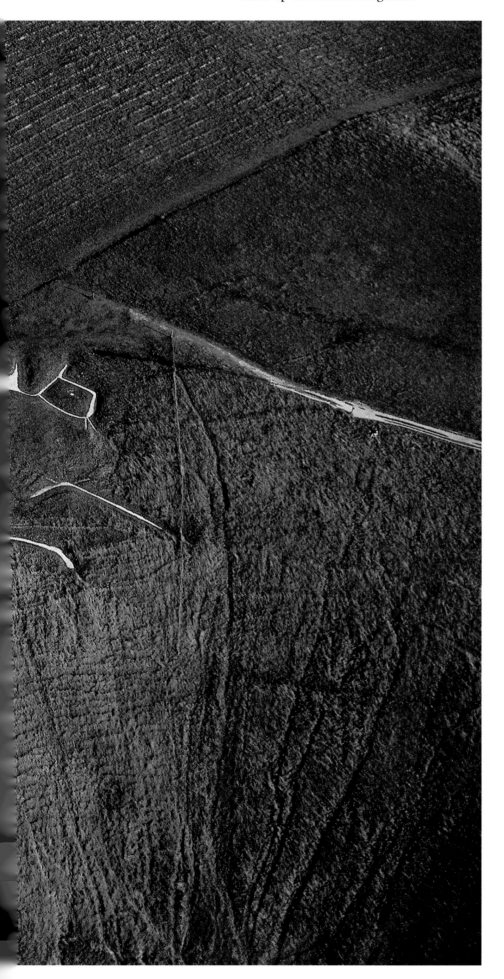

Now you see it, now you don't – at least if you are next to it on the ground. And what is it exactly? The long white body and the four legs are those of a huge 'horse' – one carved into a limestone hill in Uffington in England more than two thousand years ago. (Look below the feet in the photograph and you can clearly see the rock wall below.)

With a length of more than 100 metres, this fantastic carving was never seen in its entirety until the invention of hot-air balloons in the 1700s. Scholars think it was carved by an ancient people as a way of honouring and seeking help from one of their goddesses, who was usually represented in the guise of a horse.

But if these ancient people couldn't fly up to see their carving, how could they make it so accurately? Here is how. They first made a small drawing in the ground. Next they drew over that a grid – a series of boxes covering the picture. Using the individual boxes and the part of the drawing each of them contained as a guide, carvers went to work carving out the larger sculpture, bit by bit, in the rock. But only hundreds and hundreds of years later did the world come to know what was there!

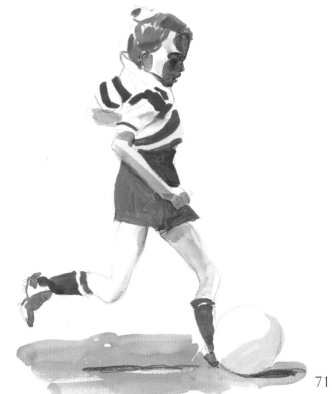

71

A lone shady spot

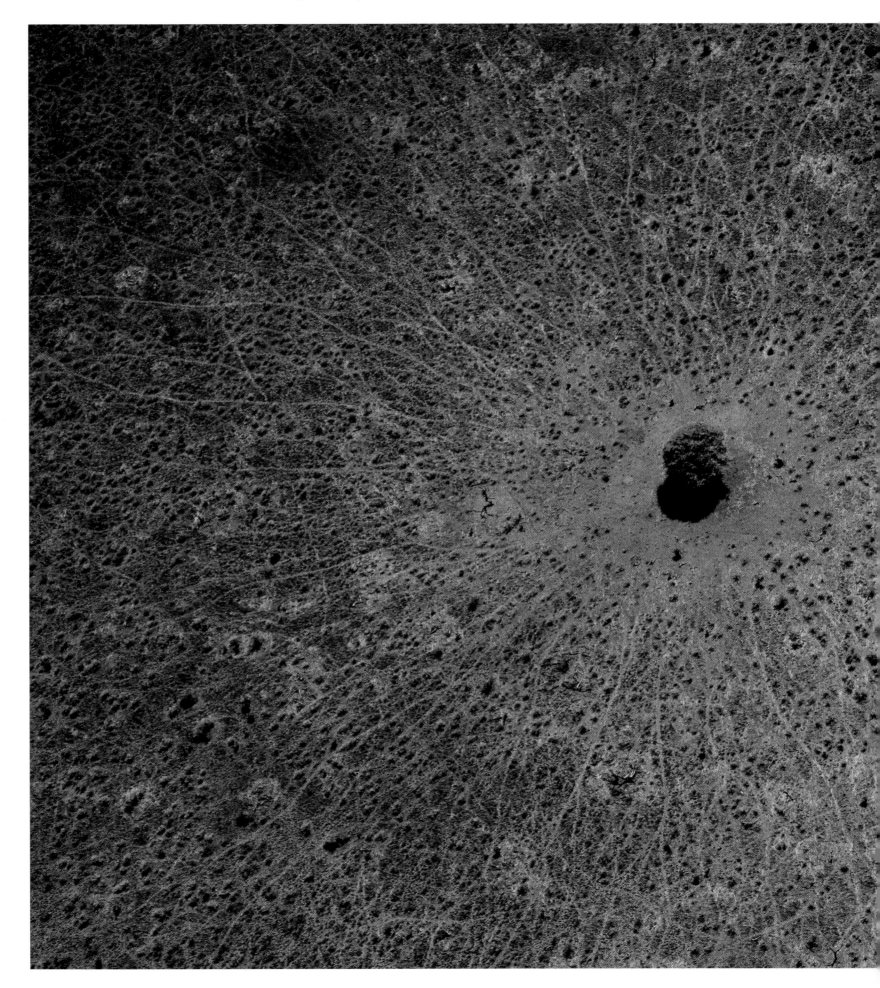

At first it almost seems to be a web with a green ball in its centre. But the centre is really a single tree, growing in a very dry, isolated landscape.

The tree (an acacia, a tree with deep roots) is growing in a section of a national park in Kenya. A national park is a large area set aside by a country to protect the space from … humans! Here there is no hunting, no digging, no building of houses. The park is guarded by rangers, who make sure the park rules are observed by visitors.

And many visitors come, mainly to see the wild animals in their natural settings. Because the acacia affords shade, it is a favourite stopping place for animals – and it is the animals that, by moving back and forth on their paths, have created the reddish 'sun rays' that seem to flow out from the beautiful single tree.

Pink flamingos

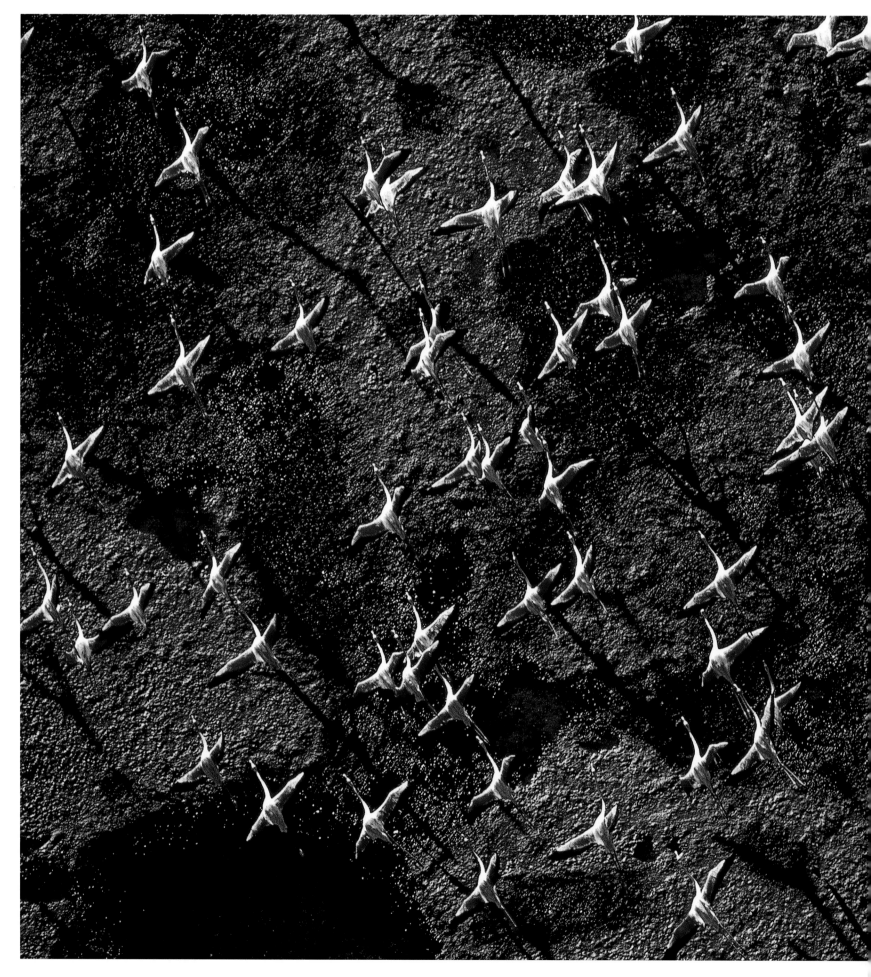

Mauritania is a country located in the northwest corner of Africa.

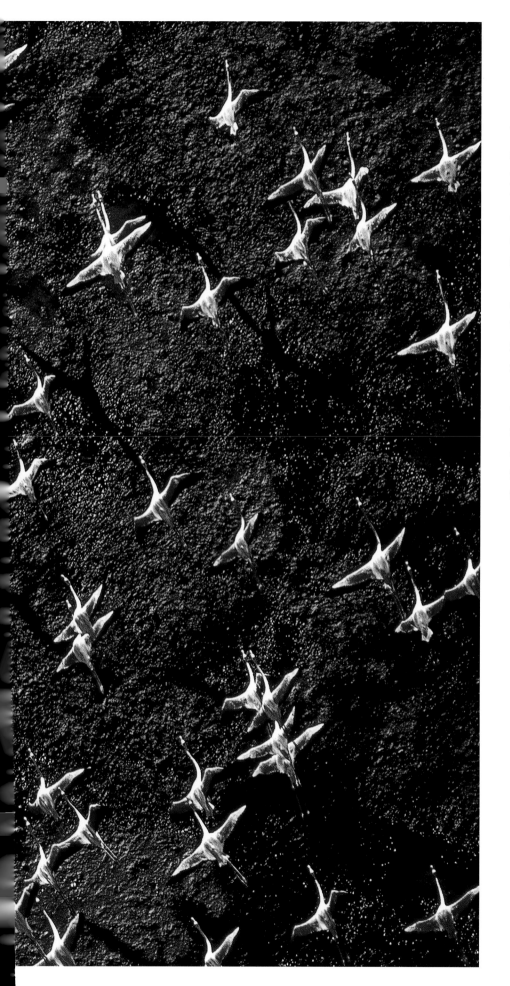

With their wings outstretched, their necks straight ahead and their legs pointed rigidly backward, these pink flamingos seem almost like mechanical gliders as they fly over a swampy area in Mauritania. Strangely enough, flamingos run awkwardly on their thin legs as they prepare to take off, but once in the air they seem to glide without any effort at all.

It's a good thing, too, that they fly with little effort. Flamingos migrate each year, travelling thousands of miles. Unlike storks and cranes, flamingos can withstand cooler temperatures, which means they fly further north than their 'cousins'.

Soon these flamingos will land, however. They will wade in the marshy area below them and dip their long beaks into the muddy water to find small crabs and algae (which are partly what give them their reddish colour). Then it's up and off again on their long journey.

A plant takes over

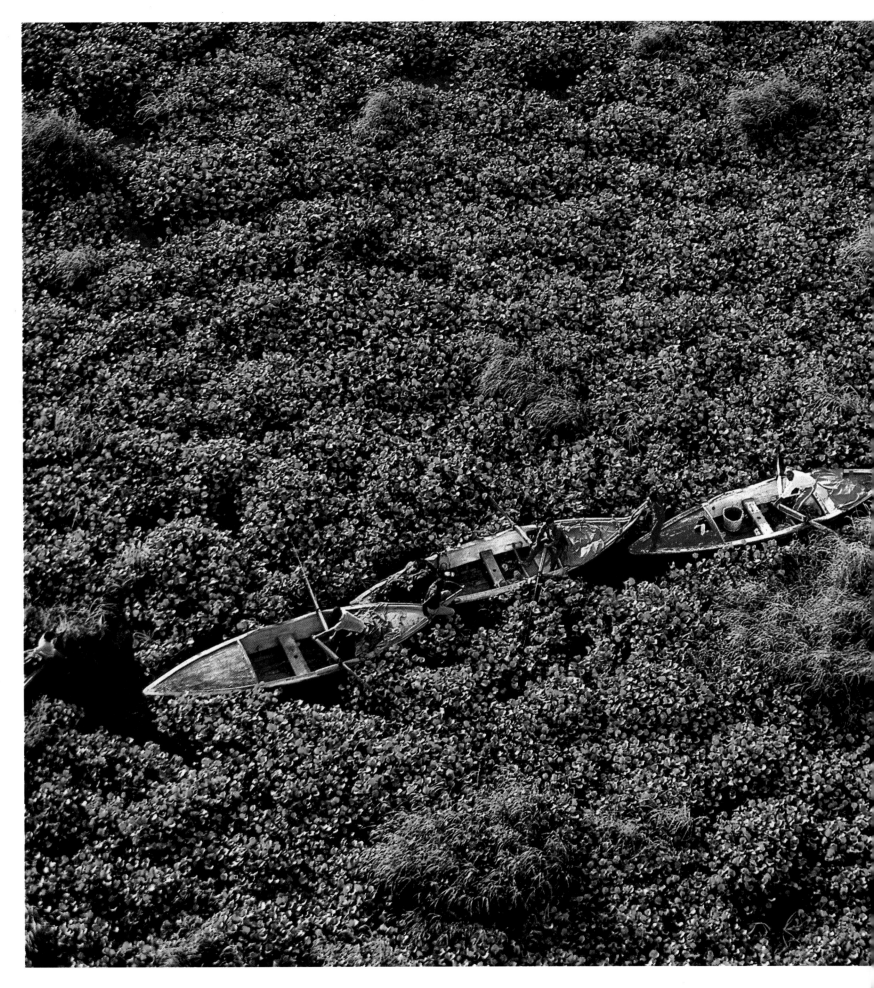

Egypt's Nile River is one of the most important waterways in the world.

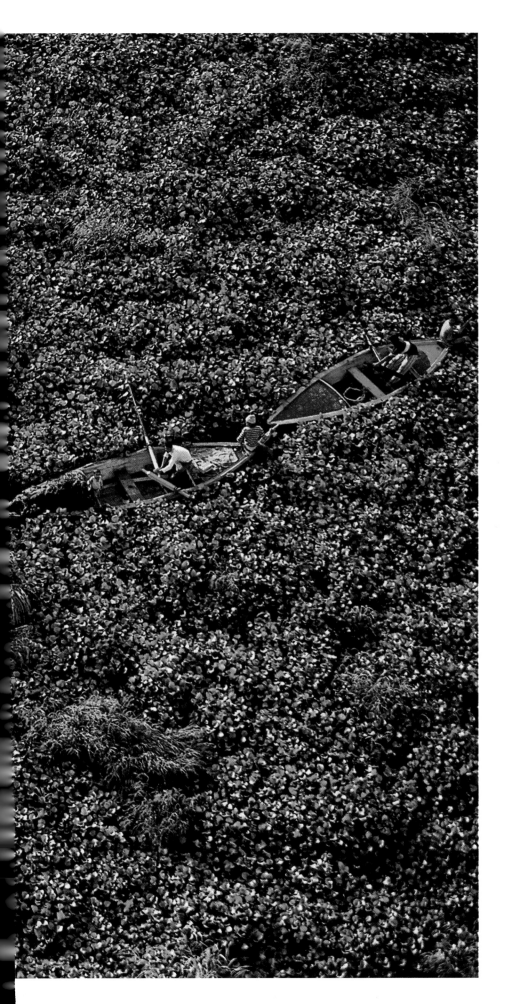

A quick glance might lead one to think these boats are skimming over the top of a thick green forest. But if you look at the first boat (on the left in the photograph) you can see a section of dark water. But why take your boats through such a tangle of vegetation?

The fact is, Egyptian boatmen have little choice. The green plant they are rowing and pushing through is the water hyacinth. It's a plant that grows very quickly. If not stopped in its growth (which is no easy task) the water hyacinth 'suffocates' the water it grows over. It blocks all transportation and kills the fish. It even harbours disease-causing bacteria.

And how did the water hyacinth get to Egypt? It was brought from Brazil years ago because people thought it would decorate their garden ponds. How wrong they were! The plant spread (and is still spreading in more than eighty countries around the world). You might say it is much too much of a good thing.

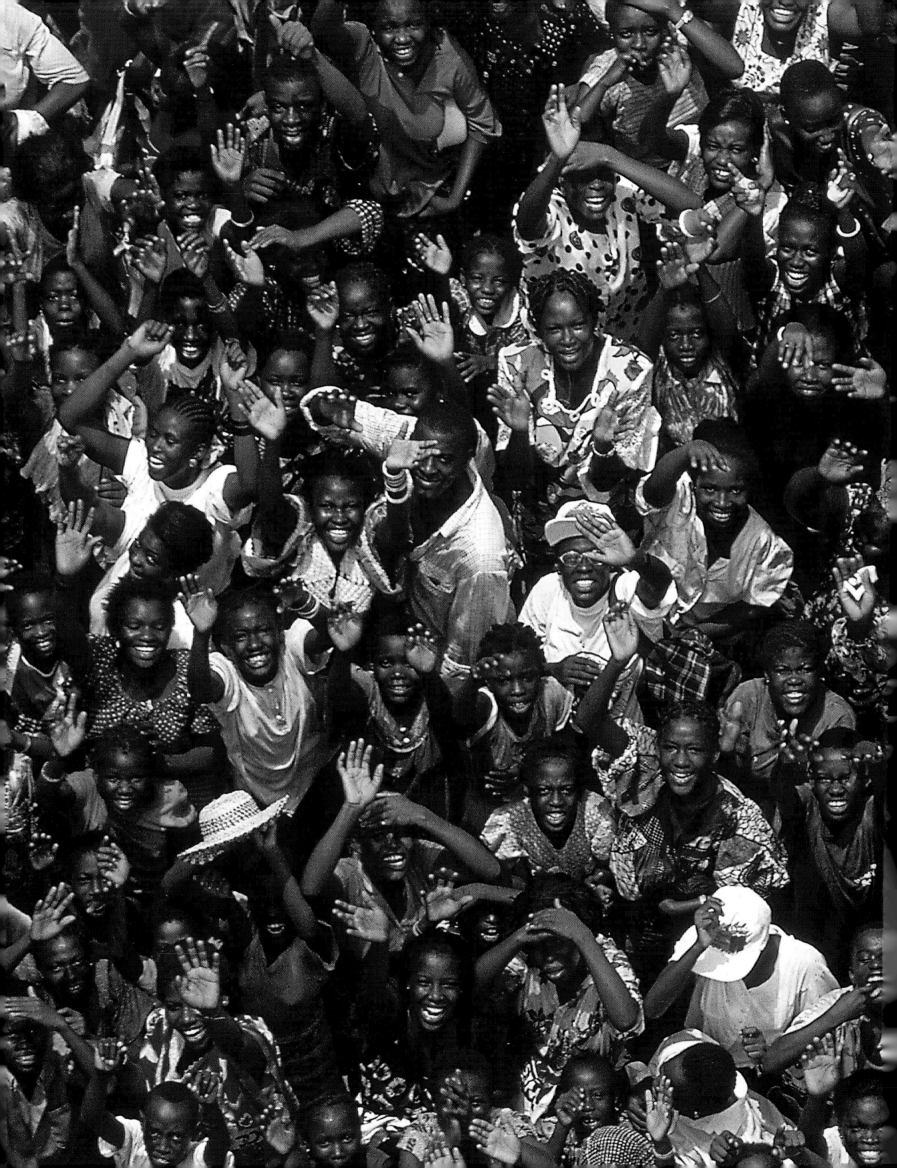